the KODAK Workshop Series

Building a Home Darkroom

the KODAK Workshop Series

Building a Home Darkroom

Written for Kodak by Ray Miller

the KODAK Workshop Series

Helping to expand your understanding of photography

Building a Home Darkroom
Written for Kodak by Ray Miller, REM Photos, Inc.

Kodak Editors: John H. Stone
 Martin L. Taylor

Book Design: Quarto Marketing Ltd.
 212 Fifth Avenue
 New York, New York 10010

 Design by Roger Pring

Photography: Ray Miller, pp. 8, 9, 10, 12, 17, 18
(top), 19, 21, 23, 31, 32, 35, 36, 37,
38, 42, 43, 46–66 (all), 70–79 (all),
80, 81, 82, 86, 87, 88, 89, 92, 93,
back cover; Tom Beelmann, cover,
pp. 2, 6–7, 11, 13, 15, 16, 18 (bottom),
20, 25, 26, 27, 28, 29, 30, 34, 40–41,
45, 67, 69; Lester Lefkowitz, pp. 84, 85;
Tom Carroll, pp. 90, 91; John Fish, p. 83

Consumer/Professional & Finishing Markets
Eastman Kodak Company
Rochester, New York 14650

Kodak Publication No. KW-14
CAT 143 9991

Library of Congress Catalog Card Number 81-66622
ISBN 0-87985-273-9
10-81-GE New Publication
Printed in the United States of America

KODAK, EKTAMATIC, EKTAFLEX, and DATAGUIDE are trademarks.

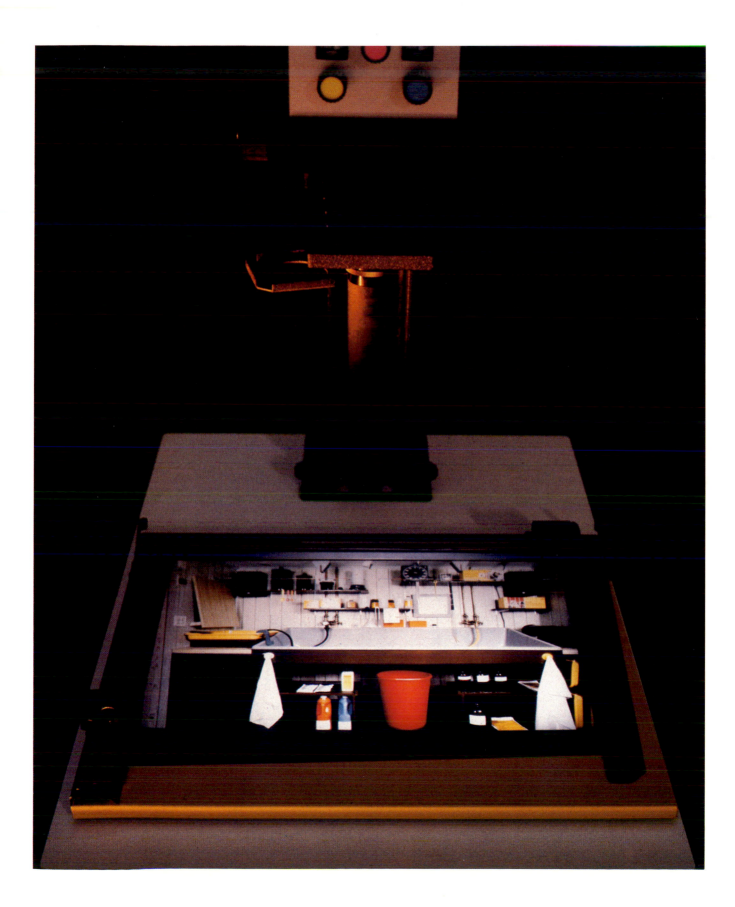

Contents

This is just a sampling of the results you can achieve in your own well-planned, well-equipped home darkroom.

Introduction

Congratulations! And welcome! It's exciting to find another pilgrim in search of a better darkroom. And you must be fairly serious about your darkroom work, or you wouldn't have bothered with this book. You're probably acquainted with black-and-white procedures and possibly color. Your prior knowledge will help you to understand some of the recommendations we'll make and will help you with your own planning. If you've only read about making finished prints in the darkroom, follow along. We'll try to make the appropriate explanations along the way.

Here's what's going to happen in this book. First, we'll give as much general information about constructing a darkroom as seems necessary—the considerations that will make your printing and processing easier

and more successful. Then we will tell you how we applied these generalities to a basement niche that we found. This niche, incidentally, was far from ideal. The basement supported a 50-year-old home that was last used as a dentist's office. No special care or attention had been paid to the basement in nearly 20 years. Fortunately, the walls and floor were solid and the area was dry.

Main concerns—preliminary planning, layout and design, plumbing, electrical work, rough and final construction, and installation of equipment and fixtures—will be treated separately and, where possible, in chronological order. We'll provide a series of general suggestions for each major consideration, explain those suggestions, and then apply or adapt

Transforming a dingy basement, an unused bedroom, or a cluttered storage area into an efficiently functioning darkroom is the dream of many photographers.

the ideas to our own basement darkroom. We start with flaking concrete and end with an efficient, working (and rather nice) darkroom.

There are many ways to go about building a darkroom. You can build it yourself or you can hire a contractor. You can let specialists do part of the construction and add the finishing touches yourself. Whether or not you intend to hire out some or all of the work, prepare accurate plans. This will also help contractors make realistic and consistent bids. (Inviting competitive bids can save you money on a darkroom as it can on other construction projects.)

Since there are dozens of helpful books that teach basic carpentry, plumbing, and electrical work, we'll leave the building skills instruction to them. If we show you what to do and where to do it, the how-to books will describe the basic skills necessary to complete the tasks. If lack of experience makes you hesitant, proceed slowly, learning as you go. Perhaps a friend, relative, or neighbor can give construction hints.*

Important! The one job where you don't want to feel your way along is the electrical wiring. Electricity is fairly dangerous and a single mistake can be fatal. If, however, you've wired fixtures and boxes elsewhere, there's no reason not to attempt the fairly simple wiring required by a darkroom.

Plumbing is important too. Incorrectly installed plumbing may not zap you, but it could cause contamination of your water system, malfunctioning drains, odors, leaks, and, ultimately, major costs for repairs.

Check your local building codes to determine if you will need any permits to do this work, what parts require inspection, and when inspections must be scheduled. A contractor will generally know what permits and inspections are necessary.

Check the insurance laws in your state when hiring others to work for you. In some states the contractor must provide a certificate of insurance to prove self insurance against injury and liability. If the contractor does not carry this insurance, you must acquire it or risk a lawsuit if someone is injured on the job or if there is damage to property other than your own.

Our first step will be to explain exactly what happens in a darkroom, and what's required of an environment to provide high-quality photographs and to make the operations consistent, efficient, and comfortable. Following that brief essay, we'll discuss preliminary planning, including finding a location, determining size, planning the layout, and making any preparations or changes in the existing space before starting the darkroom.

Actual construction comes along next—we discuss typical, general, and specific darkroom practices and then show you how we included them in building our darkroom. You'll see how three depressing, stained, cracked concrete walls and a perforated partition gradually evolve into a room where you would eagerly anticipate spending cheerful blocks of time.

The end of the book shows a number of individual approaches to darkrooms. In this section, comments from the owners, planners, and builders will add extra perspective that might help you in your own specific situation. Now it's time to examine what happens in a darkroom.

*Note that throughout this book references to electrical wiring, plumbing supplies, and lumber dimensions are nominal U.S. usage. Practice in other countries with differing measurement standards and building methods will vary from those shown in this book.

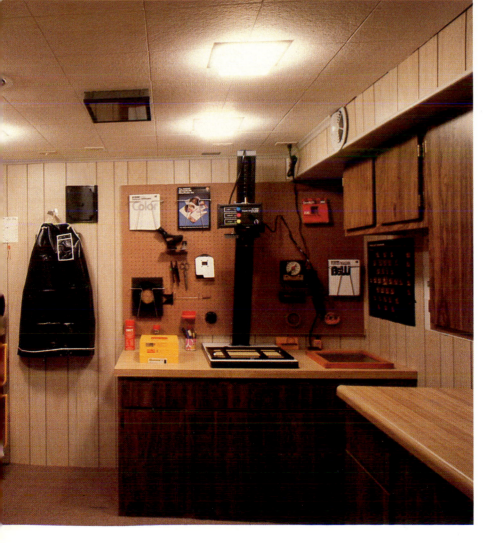

Darkroom happenings

Any number of photographic functions can be performed in a darkroom, but the two cornerstones of all darkroom creation are processing and printing.

Processing includes both film and paper. Considering the many kinds of films available (for both camera and enlarger exposure, color and black-and-white), you'll find a strong resemblance in the processing steps. Papers, too, enjoy a family feeling in processing. Generally, if you can master one procedure, you can acquire the rest with ease.

Most printing operations are remarkably similar. Whether you make contact prints from large-format negatives or enlarge 35 mm transparencies, the concerns are much alike. Enlargements, of course, require an enlarger, a timer, and for color, a voltage stabilizer. But the idea is the same. You make an exposure through a photographic image, color or black-and-white, negative or positive, onto a photo-sensitive material: color or black-and-white, paper or film, panchromatic or high-contrast, and so on. You need to control the light getting to the material being exposed, and you have to make sure that the darkroom is really dark. Clean dry space and availability of electricity are necessary for any printing operation.

Handling and processing color films or pan-sensitive black-and-white films usually requires *absolute* darkness. Films are extremely sensitive and the least amount of light will create havoc. Your darkroom must be lighttight. Film processing also requires the ability to stabilize chemical temperatures within rather strict bounds. It's handy to have hot and cold water available and, of course, drainage, so that you have a place to dispose of used solutions. You'll use the water to dilute packaged chemicals, to control the temperature of working solutions, and to wash films after processing. Printing on film is similar to printing on paper.

Film processing usually requires absolute darkness. You must load film developing tanks in the dark and cap the tank with a light-tight top if you wish to process the film in the convenience of a lighted room.

Processing or printing on photographic paper, color or black-and-white, usually requires the same basic facilities as film—a lighttight work area and access to hot and cold water with drainage. Although most papers don't demand that you work in absolute darkness, they specify what light conditions—meaning special safelights—you can use. The best approach is to start with complete darkness and add safelights. Naturally, processing usually means chemicals and temperature-controlled water for mixing, dilution, and temperature control for working solutions. Obviously, drainage should complement the water supply. Note that processing of black-and-white stabilization papers such as KODAK EKTAMATIC Papers and color materials such as KODAK EKTAFLEX products requires no chemical mixing and no running water in the darkroom.

You'll also need space—space in which to locate an enlarger and space for processing trays, a stabilization processor, or a motor-driven processor.

And you'll need electricity to power the safelights and the enlarger, to make the timers run (for enlarger and processor), and to power the motor in any kind of processor.

Neither the KODAK EKTAFLEX Processor for producing color prints nor the KODAK EKTAMATIC Processor for processing black-and-white prints requires running water in the darkroom.

PROCESSING AND PRINTING SUMMARY
1. Processing film requires
 a. Complete darkness
 b. Hot and cold water (to mix chemicals, to stabilize temperature, as wash water)
 c. Drainage (of dilute chemicals, of wash water)
 d. Electricity (optional for timer)
2. Printing on film or paper requires
 a. Complete darkness (plus safelight for most papers, some films)
 b. Space (for enlarger, for paper and film storage)
 c. Electricity (for enlarger, for safelights, for enlarging timer)
3. Processing papers requires
 a. Complete darkness plus safelight
 b. Hot and cold water (to mix chemicals, to stabilize temperature, as wash water)
 c. Drainage (of dilute chemicals, of wash water)
 d. Space (for trays or processor)
 e. Electricity (for processor, for safelights, for process timer)

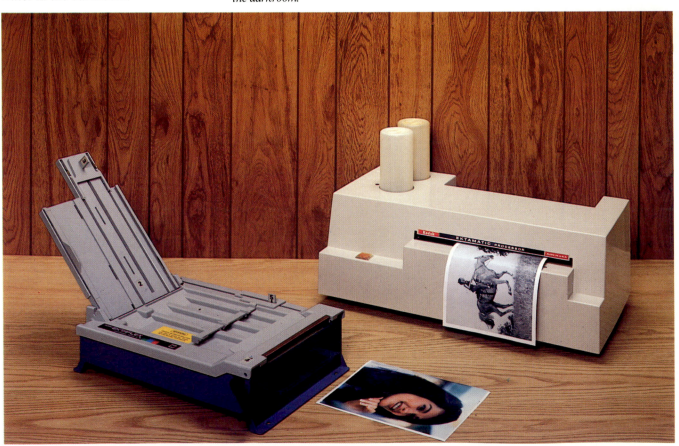

DARKNESS

Have you ever considered the irony of building a darkroom—of spending money to make a place really dark, especially when we're so concerned about the money required to provide light? Probably not. Anyway, this is a special kind of darkness—photographic darkness. And there are even two levels of photographic darkness—one for most films, and the other for some kinds of paper.

Most films need total darkness—the absence of any light whatsoever. We'll give hints throughout this book on room darkening techniques. We'll talk about "safelights." Safelights have specially designed color filters that allow a limited amount of certain wavelengths for illumination in the darkroom. Even "safelights" can expose photo materials if they are located too close to the working surfaces, if the filters are old and faded, if the bulbs are too strong, or if the time of exposure under the safelights is too long.

Here's a test of adequate room darkening. Take a sheet of white paper into your chosen area. Make the area as dark as you can. If, after 5 minutes, you can see the paper at all, it's not dark enough. One idea should be obvious—a good north-light studio does not a good darkroom make. In fact, the fewer windows and doors (and any potential light admitters) you have to face in the beginning, the easier darkening will be.

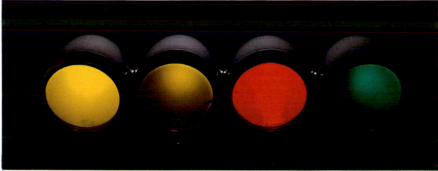

Photographic paper would be exposed and rendered useless by common light sources such as sunlight, tungsten, or fluorescent light. Most paper, however, is blind to light of a special color. Safelights emit the light that you can see to work by, but that won't expose the paper. (Different papers and some films require different color filters in the safelight housing.) See page 36 for details on testing safelights in your finished darkroom.

These are the common safelight filters you may need in your darkroom. From left to right they are the KODAK Safelight Filters OC (Light Amber), No. 10 (Dark Amber), No. 1A (Light Red), and No. 3 (Dark Green).

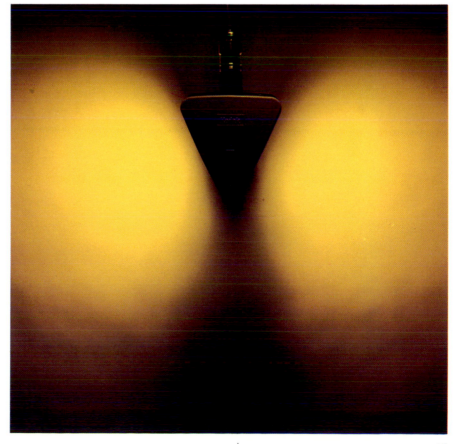

You can orient the KODAK 2-Way Safelamp to make best use of the illumination pattern.

Openings

Wherever there is an opening in the darkroom, you must be careful to exclude light. Ideally, windows should be permanently sealed and masked. Where this cannot be conveniently done, a temporary blind may serve to exclude light. Great care should be taken to seal cracks around doors that open and close.

One way to avoid the opening and closing door is to construct a maze doorway. Such a doorway must be sufficiently deep to exclude the direct light from another room. Paint the inside of the maze dead black to cut down on any reflected light, but paint a white line around the maze at eye level to aid in finding your way through.

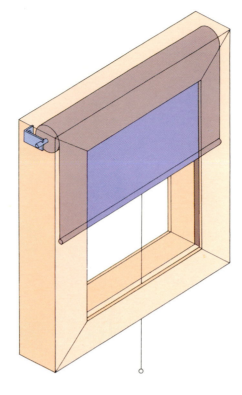

An enclosure for an opaque roller blind can be constructed to provide darkening of a room used temporarily for a darkroom. Usually this kind of blind does not provide sufficient darkening for film safety, but it is adequate for black-and-white printing.

There are many ways of excluding light around a conventionally-opening door. Weather stripping and draft-excluding thresholds are convenient aids. A sliding pocket door is one rather handy method of constructing a lighttight darkroom door. With the track pitched correctly, the door can be made to close lighttight with just a touch.

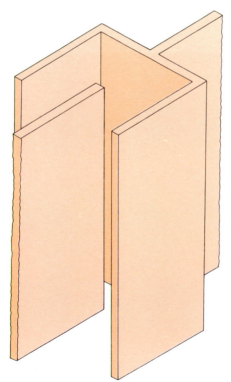

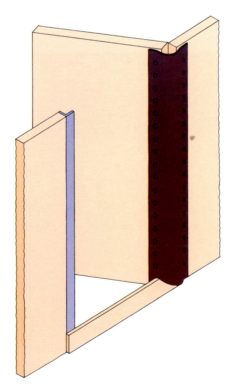

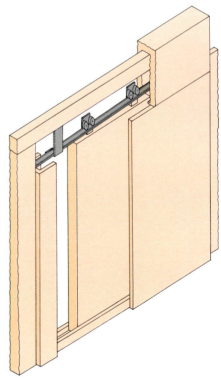

A maze entrance for a darkroom is usually sufficiently effective for black-and-white printing. Adding an opaque black curtain on the inside of the opening can make the entrance suitable for color printing or film developing as well.

Baffles at the top, sides, and bottom of a darkroom door will exclude light. Where a baffle would interfere with the hinges, a flexible strip can be attached to the door and doorframe with sufficient material left free to allow the door to open and close normally.

A pocket door built into the darkroom wall can easily be made lighttight and it allows easy opening and closing. By slightly pitching the track toward the closed position, you can make the door self-closing.

WET PROCESSING

As we've discussed, most photographic processing requires water, both hot and cold, and a place to flush away what's used, exhausted, or left over. Your darkroom location should make use of any convenient water supply. Perhaps that's why permanent basement installation and temporary kitchen and bathroom facilities are so popular. The water should be clean (see test page 26) so that foreign matter doesn't throw off your processes and so that your equipment, film, and prints don't end up with gummy or gritty deposits. You'll want both hot and cold water because most processes require or recommend a specific temperature for one or more chemicals and that temperature may need to be extremely accurate. It's handy to make most working solutions with water that's fairly close to the specified temperature, so that later stabilizing for the process (by immersing the containers of working solution in a waterbath) will involve only minor adjustment.

Many chemicals arrive in powder form. You convert them to stock solutions by mixing with water. There is often a temperature specified for this first solution. Making working solutions requires further dilution.

The need for drainage is obvious. What's not obvious is that the waste from photographic processing should be disposed of carefully. If, in fact, you carelessly dump waste chemicals down the laundry tub drain, you may be violating a sanitary code. It's wise to check out your sanitary sewer or septic tank and leach field with an expert to determine how (and where) you'll handle your drainage. Most people will encounter few or no restrictions for small quantities produced in home darkrooms. But those who do may only have to use a holding tank to precipitate out undesirable wastes (and perhaps silver).

A water bath can keep processing solutions at a constant temperature for the duration of the process. The temperature variations must be strictly controlled for photographic processing to get consistent results.

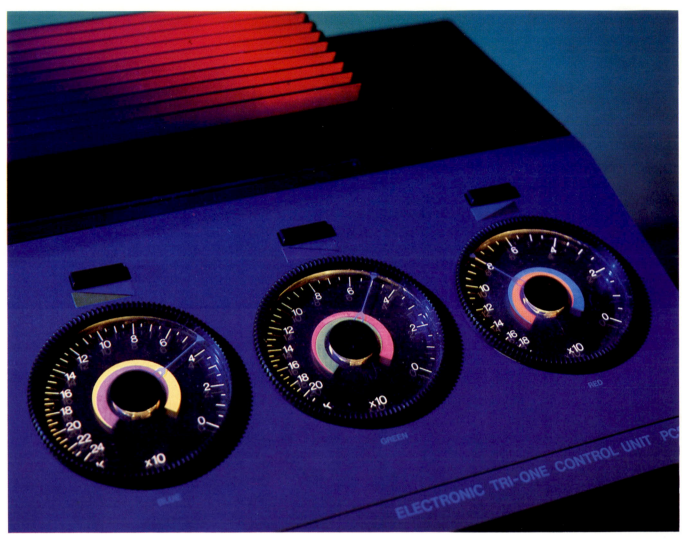

Color printing requires an electrical source of constant voltage. Some controllers for color enlargers have built-in constant-voltage transformers. Others may require a separate transformer to supply constant voltage to the enlarging lamp.

POWER FOR PRINTING

We generally take easy availability of electricity for granted. Not so for the photographic printer who desires consistency and repeatability with a negative or transparency. The careful printer will want not only raw input of electricity, but a measured and constant flow to make sure that colors, tones, or exposure remain the same. As voltage fluctuates with use in a heavily loaded electrical service, so will print quality, because light produced by the enlarger lamp changes color and brightness with changing line voltage. When the power stays the same, so will the enlarger bulb, helping assure that print exposure and tone or color will be consistent.

Another fairly sensitive piece of equipment is a roller print processor which may agitate faster or slower depending on the voltage reaching the motor. For consistent results, the processor should run at a constant speed, meaning in turn that the line voltage should be stable.

Of course, there are other electrical requirements you'll need to consider: room lights, safelights, accessory outlets, ventilating fan or air conditioner, heater in winter, and dehumidifier to protect your equipment in humid weather.

CONDITIONED COMFORT

Mentioned under electricity, were ventilating fan or air conditioner, heater, and dehumidifier. As you've guessed, these items all contribute to your comfort and the well-being of your photographic equipment. A ventilating fan to the outside or an air conditioner will keep fresh air circulating in your work area. You won't have to breathe chemical odors, and the eviction of air-borne moisture may help prevent the condensation and drying cycle that will accumulate amounts of contaminating chemical dust all over your darkroom.

A heater or air conditioner will warm or cool you as the season demands. But they'll also provide an improved environment for stabilizing the temperature of process chemicals, and in the case of the air conditioner, help to deter the harmful effects of summer heat on chemicals and sensitized goods.

Traffic refers to the number of people besides yourself who will enter your darkroom. Ideally, no one will ever be going through it without an invitation. The fewer careless hands on sensitive instruments and photographic chemicals, the better. It's not always possible, however, to be so restrictive. Choose your location and make your design with the possibility of traffic in mind.

An air conditioner not only cools the room air but also extracts moisture from the air to provide some measure of humidity control as the wet bulb-dry bulb thermometer indicates.

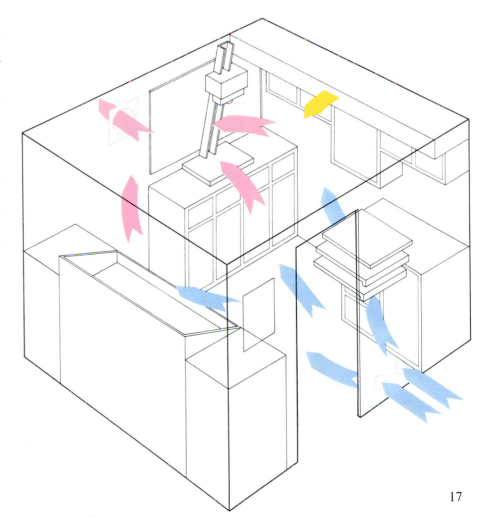

Arranging appropriate inlets and outlets for air will provide uniform, directed flow for exhausting moisture-laden air.

WORK FLOW

Space is necessary for every endeavor. By careful planning (see pages 20-34) you can create an efficient and compact area that will conveniently handle all your needs for elbow room. As we mentioned, you need space for processing—not much for roll film but definitely a fair amount for sheet film and paper prints. The bigger the prints, the more space you'll need for processing trays or a processing tube or drum. A photographer regularly making 16 x 20-inch prints will want more room than the person who desires only 8 x 10s.

Many people build or buy a special sink for their trays or processor so that chemicals and water will stay put, away from unexposed paper and sensitive electronic equipment. A big sink or sink-and-counter assembly requires even more room. And you'll want to have a place to dry prints and film. Storing chemicals in the darkroom is a good idea too—away from small children and potential accidents.

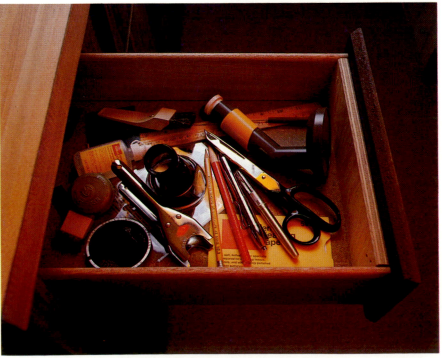

*Everything at hand and everything organized to be found in the dark without fumbling—that is the ideal for a darkroom. Obviously the drawer shown **at left** could be better organized with dividers; a kitchen tray intended for knives, forks, and spoons makes a useful drawer organizer.*

Making an enlargement presupposes a certain guaranteed space. The enlarger must be placed somewhere—whether on a table, cabinet, or mounted on the wall. The enlarger is usually adjacent to a timer or even an analyzer, both taking up room. Makers of large prints—16 x 20 and bigger—should consider a setup where the enlarger base can be lowered, which requires vertical space. Paper should have a dark, dry habitat—preferably some place in the darkroom and this, again, requires space.

Work flow means having your operation flow smoothly in one direction without side trips or back-ups. Work flow means starting at point A and arriving at point B without lost motion and without endangering the integrity of your process. If, for instance, you set up your enlarger with the timer and paper supply on the left, imagine the convenience of removing exposed paper to the right, entering the developer tray, removing the paper to the right to the stop, right again to the fix, and so on until you reach your drying rack. That's work flow—a convenient, efficient, continuous pattern that helps you work faster, smoother, and more accurately. Work flow is a concept you'll want to consider in the planning and designing stages of your darkroom.

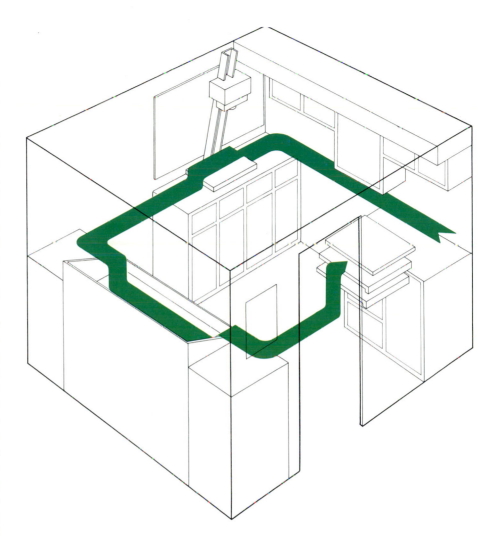

Organize your darkroom so that work progresses in an orderly fashion without backtracking. In this darkroom, work flow is designed to proceed from right to left. You may prefer a design that provides work flow from left to right.

Planning

What should you do first? Preliminary planning is the answer. We'll discuss locations, design, size, and any preconstruction mechanical or building operations that need to take place before the start of actual darkroom construction. One last word—planning is the key to success in most photographic enterprises. Careful thought about the preliminary aspects of your darkroom project may save you money and time—and possibly some heartache.

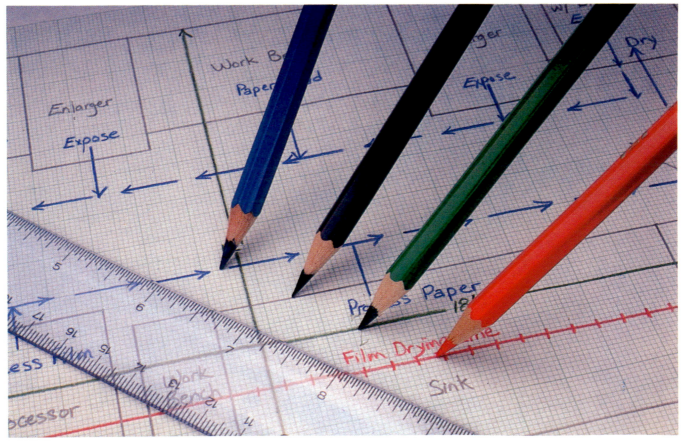

LOCATION

Nearly any area that can be made lighttight is a potential darkroom location. A kitchen or bathroom installation must obviously be temporary and portable. The advantages of these items are, of course, running water, accessible drainage, and usually, plentiful electricity. Also, you can use a spare room, an attic, a large closet, a bedroom, or a den in its entirety or partition off a corner for your darkroom. Leave the rest of a large room as a work room for print finishing, filing, slide duplicating, or other photographic enterprises. (Usually though, it's wise to commit only darkroom procedures to the darkroom. Keep other projects and their accompanying dirt out of the darkroom and away from damage by chemicals.)

The basement of your house might be an ideal location. The typical basement is left unfinished by the contractor—the wiring, plumbing, and heating are easily accessible. A far corner of the basement is remote enough to eliminate unwanted traffic. Of course, you may have to contend with some obstacles. Heating ducts may intrude. A low ceiling presents difficulties, too. Home builders seem to delight in breaking up the smooth expanse of all four walls with water meters, gas meters, electric meters, hot-water tanks, furnaces, and laundry tubs instead of confining all of these things to one area and giving you three corners and the better part of three walls unencumbered. Consider this if you are building a new home. Also think about adding an extra course of cement blocks on the foundation to provide additional head room, which should also add value to the home. Designing in an extra drain allows placement of piping before the concrete floor is poured.

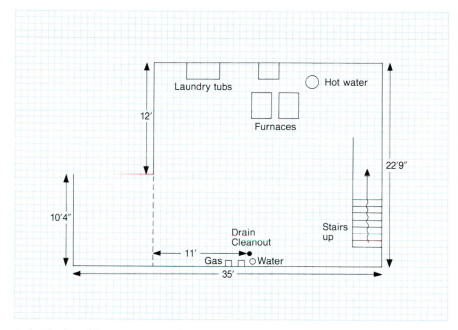

A sketch plan of the entire area under consideration will give an immediate idea of potential darkroom locations and the direction and distance of such services as water, drains, and electrical circuits.

Measure carefully so that you can determine accurate dimensions on your plan. Remember that partitions have significant thickness (about 4½ inches).

LAYOUT AND DESIGN

Once you've chosen a location, the next logical step is to begin a set of plans. You'll want to outline the area you're going to use and work out how the equipment will be arranged. Size is the first consideration.

Make up your equipment list. Measure each major piece that will take up floor space. Include work benches as well as the sink and allow enough counter space on both wet and dry sides for trays, processors, enlarger, trimmer—whatever you'll need. Then carefully measure the entire area in which you expect to construct your darkroom. Now you control most of the design variables. The next step is get these variables on paper.

Colored blocks define each piece of equipment to go in our darkroom. As you can see, we tried several arrangements for our darkroom before settling on the last one (far right) as the best.

No matter how small your area, you'll want to provide as much separation as possible between the wet side for processing and the dry side for enlarging. That's necessary to prevent water splashes or chemical contamination. The separation will keep splashes from reaching the areas where you will be handling film and paper.

Here are the materials you will need to draw plans for the construction of your darkroom and the location of equipment:

Graph paper (8½ x 11 inches with ¼-inch square)
Tracing paper (9 x 12 inches)
Pencils and erasers
3 x 5-inch file cards—8 or 10 should be enough
Ruler—an architect's scale is perfect, but any accurate rule is OK. (A drafting set would be handy as well as a T-square and 45-degree and 30/60-degree triangles. Accuracy is important to provide useful information for whoever is doing the building.)

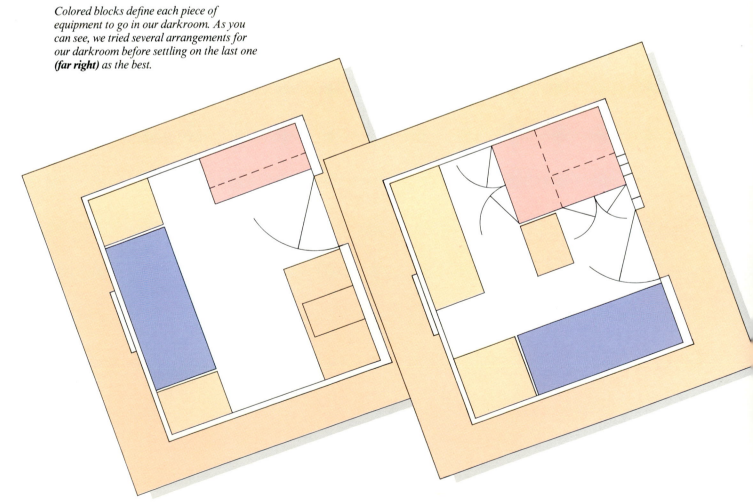

While graph paper and an accurate ruler are all that are really necessary to complete the plan, you will find that a T-square, triangles, and other drawing instruments will make the task easier.

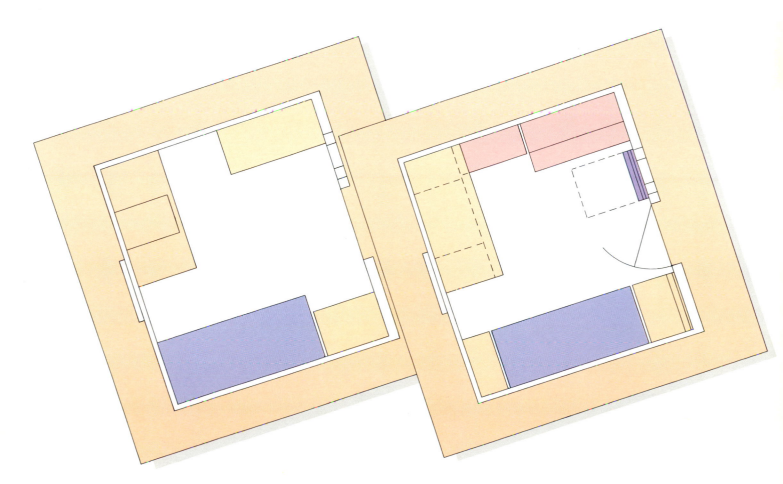

DEVELOPING A PLAN

1. First, make a scale drawing of the space available for your darkroom on graph paper. Try a scale of ¾ inch or 1 inch equal to 1 foot (three or four squares to the foot on your graph paper). This scale will be adequate for any area up to 8 x 10 feet; for larger areas tape two pieces of paper together or choose a smaller scale.

 Then, make a drawing of the area surrounding the darkroom site to locate the utilities such as electric panels, furnace, drains, water inlets, hot water, and so on. For this larger area use a smaller scale of ¼ inch (one square) equals one foot.

2. On the large-scale drawing of the darkroom area, locate all permanent fixtures such as heating pipes, floor drains, gas, electric, or water meters, and other intruding objects.

3. Make a tracing of this basic area drawing and indicate anything that should be moved (electrical lines or boxes, pipes, ductwork, and so forth) and its new location. Some of the items last mentioned should be moved to provide you with cleaner building surfaces or to provide later accessibility to important utilities. Show the new locations of the items on all subsequent tracings made from this basic drawing. (You will need tracings of the basic drawing for electrical, plumbing, and partition construction as well as three or four copies for sample arrangements of photographic equipment.) These drawings may also be sufficient to satisfy requirements for a building permit should one be required.

4. Using the file-card stock or any thin cardboard, cut out and label blocks for each piece of major equipment. Use the same scale as your detail drawing—¾ inch or 1 inch equal to 1 foot. By moving these blocks around on the tracing, you can plan the most efficient use of the space you have available.

5. There are two approaches to organizing space. If you are working in an already enclosed area or have space restrictions that will limit the area used, move the equipment blocks around until you feel comfortable with the work flow pattern. Remember you want your

feet and hands to follow an efficient path—starting with removing paper from a paper safe, through exposing it on the enlarger, through the processing steps, until it is finally drying. Plan to work in one direction so that your feet and hands don't get crossed up. You save time, limit chemical contamination, and develop a rhythm that will help prevent mistakes.

Use the second method of developing a floor plan for the corner of a room or basement. Start by drawing a plan showing just the two corner walls. Using your equipment cutouts, place the equipment to your satisfaction. Then simply draw partitions around the layout and you have your darkroom planned. Plan to use the rest of the room for a workshop, a laundry, or even a small recreation room. (A laundry makes a convenient place for chemical mixing.)

 After you have found an arrangement you like, draw an outline of each block on the tracing and label it. This will be the floor plan of your darkroom. You may want to compare the three or four best possible arrangements for maximum efficiency.

Print washing consumes a significant amount of water. Use of resin-coated papers has reduced the time required for the wash in most processing sequences. You must follow the manufacturer's recommendation for adequate wash in both black-and-white and color processing.

WATER SUPPLY

When you select an area for your darkroom, it's wise to consider all the existing facilities. The availability and location of your hot and cold water supply is important. If you opt for a water-temperature control valve, you should have adequate water pressure. If someone flushes the toilet and the water temperature rises dramatically to 130°F (55°C) during a 68°F (20°C) wash cycle there may be trouble in your film tank.

For a water-temperature control valve to operate correctly, the water pressure must be the same for both hot and cold water (and be at a fairly high 45 psi). Although most temperature control valves are equipped with pressure-reducing regulators, a

severe drop in the water pressure will defeat the control valve and allow the water temperature to rise or fall out of tolerance. Most regulators will reduce water flow first and then lose temperature control.

If, on the other hand, the volume of wash water diminishes, your film or print may have inadequate washing and the image may not last as long as you would like. Many color processes call for a supply of 2 to 2½ gallons of running water per minute. If your system can't meet suggested supply requirements, you'll be safe with multiple still wash baths and agitation. Your system should be able to fill a gallon container from both the hot and cold taps in your darkroom in 20 seconds (3 gallons per minute). How about when someone flushes the

toilet, runs the washing machine or dishwasher, or fills the swimming pool? Although some water systems have as much as 45 pounds of pressure per square inch, normal demands on household piping may diminish the pressure markedly before it gets to a darkroom. You can help the supply situation by tapping into the cold water line where it enters the house (directly after the water filter if you install one). In this way you will have access to the water before it is used at any other outlet.

Water drawn from some wells or from other untreated sources is sometimes colored by colloidal iron or organic matter. Water in this condition can stain a photographic emulsion, but filtration with activated charcoal generally removes such impurities.

When water is heated, gas or air bubbles come out of solution, giving the water a milky appearance. This problem most often occurs when the incoming cold water is below 50°F (10°C). If these bubbles adhere to the surface of a film or paper, they interfere with processing and washing. The remedy for this trouble is aeration of the incoming water. This procedure causes the small bubbles to combine with the larger ones that disperse easily. In sinks used for hand processing, fit aerators to the water taps; most hardware stores stock these attachments.

Water Quality

Generally, municipal or public water supplies are sufficiently pure for photographic use. Such water almost always contains added chlorine and often added fluoride. Excessively hard water can be troublesome in chemical mixing. Very soft water swells and softens the gelatin on film and paper during washing.

The hardness of water is measured in parts per million of calcium carbonate ($CaCO_3$). The following table gives the quantity of this substance contained in water described as soft or hard.

Soft
Less than 40 ppm of $CaCO_3$
Moderately hard
40 to 120 ppm of $CaCO_3$
Hard
120 to 200 ppm of $CaCO_3$
Very hard
Over 200 ppm of $CaCO_3$

The practical limits of water hardness for photographic use are 40 parts per million to 150 parts per million of $CaCO_3$. The local water authority or water company can usually provide information about a particular water supply. Since there are seasonal and possibly other periodic changes in the condition of a water supply, the long-term monitoring by the water company is more reliable than the analysis of a single sample of water.

When considering any water source, and especially if you intend to use an undrinkable water supply or water from a well, have a sample analyzed. Water may contain impurities harmful to photographic materials in processing. If the analysis shows a marked deviation from the quantities shown by the table of practical limits for common impurities, you should consult a water conditioning company to determine the most suitable method of treatment or filtration of the water.

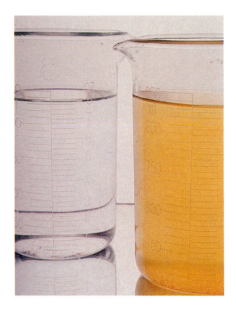

WATER IMPURITY LIMITS

Practical limits for the common impurities in water for photographic processing

Impurity	Maximum or range of content (ppm*)
Color and suspended matter	None
Dissolved solids	250
Silica	20
pH	7.0 to 8.5
Hardness, as calcium carbonate	40 (preferable) to 150
Copper, Iron, Manganese (each)	0.1
Chlorine, as free hypochlorous acid	2
Chloride (for black-and-white reversal)	25
Chloride (for color processing)	100
Bicarbonate	150
Sulfate	200
Sulfide	0.1

*Parts per million.

Water Cleanliness

A glance at the dirt particle content of your water may help you avoid the snowy negatives and transparencies that always mean hours of spotting. Draw a gallon of water into a clear glass jug from the pipe to be tapped for your darkroom. Let it settle overnight and observe how much sediment forms on the bottom of the bottle. You may want to install a water filter.

There are two basic types of water filter. One traps dirt particles with a very fine screen that can be cleaned by occasional backwashing. The other type of water filter uses a cellulose or resin cartridge to clean the water. As the dirt is removed from the water by this filter element, the water pressure slowly decreases until the cartridge must be replaced with a new one. Both types of filter are manufactured to be installed in hot and cold water lines. A less expensive one can be obtained to attach to the end of a faucet that is threaded for a hose connection. We recommend that the inline type be installed to filter all the water entering the room.

A 50-micrometre porosity filter is sufficiently fine to trap the larger particles of grit that cause mechanical damage to films and papers in processing. Filters of 25 micrometres porosity usually remove finely divided particles—such as clay, silt, mud, or silica—that cause turbidity.

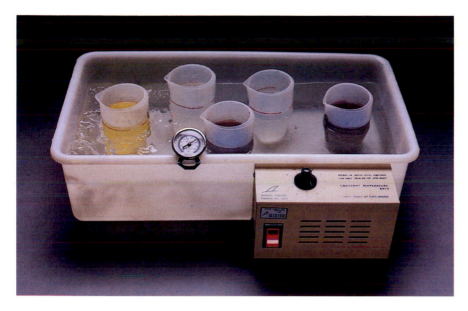

A temperature control bath with thermostatic sensor and a heating unit can ease the difficulties of maintaining solution temperatures.

Tempering Water

Hot water is another matter. Because most color processes run hotter than they used to, an adequate supply is a necessity. Get the hot water for your photolab first by running a pipe and connecting into the hot-water line as close to the tank as possible. A 30-gallon hot water tank is rather small, a 40-gallon tank is adequate, and a 60-gallon tank is too much to expect.

In some older homes the main water supply pipe to the house may only be ½ inch. Aging of the system may have reduced the once-adequate flow. If you have already had problems with achieving normal pressure or flow rate, now may be the time to consider a new, larger-diameter water supply line.

When you have only small quantities of photographic materials to be processed, you can get along with manual adjustment of water temperature. For example, you can fit the drain of the darkroom sink with a standpipe, and allow water from an ordinary mixing faucet to surround processing tanks to the level of the standpipe. With such an arrangement, you must watch a thermometer placed in the water flow to make sure that varying loads on the water-

supply lines do not change the temperature of the mixture.

With frequent or prolonged processing sessions, you will find that the manual control of temperature is cumbersome. Therefore, you will want an automatic temperature-control system that is both accurate and dependable.

In some commercially-designed chemical-tempering units, small immersion-heaters control the temperature of the water bath in which the processing vessel stands. These units maintain the water temperature in the bath within plus or minus ½°F and are capable of tempering several cubic feet of water. Most of these units have an electrical heater element, an agitator or circulator pump that keeps the water flowing over the heater, and a temperature-sensing device.

If you require a supply of tempered water greater than that provided by an immersion heater, try a thermostatically controlled, manually operated mixing valve as an inexpensive alternative. These valves operate by mixing the hot and cold water to obtain the desired temperature. The one chosen should deliver at least 3 gallons of tempered water

per minute, control the temperature of the mixed water within plus or minus ½°F, and recover quickly from variations of pressure and temperature in the water lines.

In some parts of the country, the temperature of the incoming cold water may be higher than required for the photographic processing. In these conditions you must have an auxiliary water chiller. As an alternative, you can install an entire sink unit with the chiller as well as all other processing requirements already fitted.

Tempered-water recirculating units can provide valuable savings in water usage. These units include both heating and chilling capacity, and can be connected to a water jacket that surrounds a tank or to a sink.

If the contractor connects the tempered-water-line outlet below the surface of the water in a water bath or washing tank, they should also install a vacuum breaker on the supply pipe from the temperature-control unit. This fitting prevents contaminated water from the tank being siphoned into the water lines if the main supply fails or is shut off. Both drinking water and processing solutions can be contaminated this way.

DRAINAGE

With all of this talk about water there must be some talk about disposal. A drain line to a sewer is far preferable to carrying out waste water in a bucket. You may be able to tap into the drain line from the laundry sink or enter a main drain line through the clean-out cover. Within limitations, your processing wastes can go into a septic system without consequence.

In recent years, a growing awareness of the consequences of discharging effluent into our water supplies has led to the implementing of voluntary and legislated corrective measures. It has often been observed that there is no "typical" photographic-processing effluent; however, effluents from moderate-size photographic-processing operations seldom exceed the limitations that are imposed by effluent regulations. The casual user of a one-pint tank generally can pour the expended solutions down a household drain without ill effect.

Wastes from photographic-processing solutions should not be disposed of in storm sewers, which are neither a method of disposal nor a means of treatment and merely carry

A standpipe inserted in the drain serves to raise the water level in a sink to provide a tempering water bath or for print washing.

surface water from rainstorms to the nearest stream or watercourse. Disposing of wastes in a storm sewer may create undesirable conditions in the receiving water.

Large scale or direct dumping of processing chemicals should be avoided. Holding tanks that bleed into the sewer line should be used whenever possible.

Silver is present in significant quantities in processing effluent. Free silver ions are toxic to microorganisms, but in photographic effluents, silver exists as silver thiosulfate, which is not toxic. However, most sewer codes regulate the total silver concentration. For this reason, as well as for the economic return, it may be advisable to recover the silver from the effluent.

Septic-tank systems can maintain their efficiency in the treatment of sanitary wastes and a wide variety of photographic chemical solutions, provided that the ratio of sanitary waste to photographic waste (including wash water) is kept in the range of 10 or 15 to 1, for a manual processing method. As an example, the average daily volume of waste per person going to a home septic tank is approximately 50 gallons. A family of four would produce about 200 gallons of sanitary, kitchen, and washing effluent per day. Therefore, a correctly designed septic tank in this example could handle 13 to 20 gallons of photographic-processing waste and wash water per day (based upon 15-to-1 and 10-to-1 ratios, respectively). For automatic processing machines, the ratio of sanitary to photographic waste should be about 20 to 1.

Extreme caution should be taken not to introduce into a septic tank solutions that contain sodium or potassium dichromate, which are hazardous to the bacteria in the septic tank. KODAK Developer System Cleaner and the bleach used in some reversal processes contain these compounds. In sufficient quantities, these chemicals may retard or stop the desired biochemical reactions. Dichromate in a solution can be reduced to a less troublesome form by first adding reducing agents such as sulfite or thiosulfate. Any alkaline material (including waste developer) can then be added to neutralize the acidity and precipitate the chromium. The solid chromium compound can be filtered out or allowed to settle before disposing of the solution. A second precaution is to avoid a sudden release of chemicals into the septic system, although pint-sized amounts are not likely to be harmful.

If you have concerns about the volumes of waste water you will be producing or the concentration of photographic wastes you can safely dispose of, consult Kodak publication No. J-52, *Disposal of Small Volumes of Photographic Processing Solutions for the Small User.* This publication is intended to be of help to the processor who is discharging less than 200 gallons of photographic-processing wastes, including wash water, each day.

When disposing of photographic solutions, dilute the liquids with generous amounts of water and follow recommendations for drainage.

ELECTRICITY

You must investigate the quality and quantity of the available electricity. For instance, is the supply into the building adequate? Some older homes have only 60- or 100-ampere service which will barely be adequate for the multitude of small appliances we now consider essential. If electricity is plentiful, are there existing circuits in the area of your proposed darkroom that are free of electric motors or resistance-heating devices that may make sudden, voltage-dropping demands? Does the main panel box have enough room to add new circuits just for the darkroom? Can a line be taken off the main box to supply a subpanel box?

If these questions are puzzling, you may need the help of a professional electrician. You'll also find that, since electrical code rules are changing so rapidly, the professional may be able to save you some time otherwise spent bringing your electrical services up to code. If, however, you're familiar with electricity, and the changes are not overwhelming, do it yourself but do it according to code and have it inspected.

How much electricity will you need? Total the wattage of all electrical equipment you plan to have in the darkroom—enlarger, timer, lights, safelights, drier, slide viewer, and all the rest. Divide the total wattage by 120 volts (or whatever voltage you have available). The answer is the number of amperes of current that would be drawn if everything were on at the same time. Add 10 or 20 percent for growth. Then provide one or more circuits sufficient to carry the indicated current demand in amperes. Common circuits are 15-ampere. However, by using larger wiring, you can have 20 or even 30-ampere circuits.

Put the lights on one circuit and all other equipment on a separate circuit. Then while momentary overloads may trip the circuit breaker on the working circuit, you won't be left in the dark. For color printing, a separate circuit for the enlarger may be helpful in minimizing light shifts due to changing load on the circuit if a constant voltage transformer isn't provided for the enlarger.

There are many darkroom appliances to make demands on the electrical supply. You are well advised to design for greater demands than you might originally estimate.

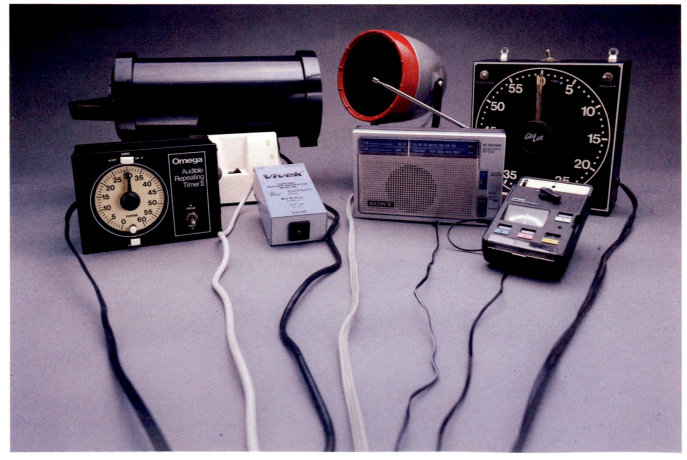

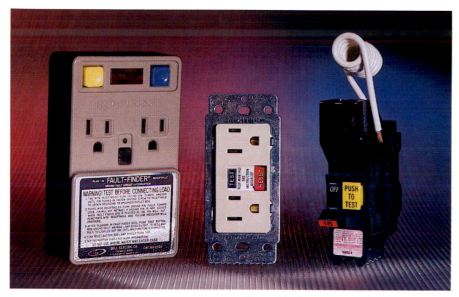

*Ground fault interrupters can protect the darkroom worker. Such a device is available (**left to right**) as a separate unit to plug into a conventional outlet, as a replacement for an ordinary outlet, or as an addition to the circuit breaker.*

ELECTRICAL CIRCUIT CALCULATION

Here is an example of how the calculation for electrical current requirements works. First, check the wattage of your darkroom equipment. Here is the list that we compiled for our project darkroom and the resulting power requirement:

Enlarger	250 watts
4 100-watt lamps	400 watts
2 7½-watt safelight lamps	15 watts
1 15-watt safelight lamp	15 watts
Exhaust fan	100 watts
Timer	30 watts
Dryer	300 watts
Viewer	60 watts
Immersion heater	1000 watts
Total	**2170 watts**
+ 10 percent for future needs	220 watts
Total power needs	**2390 watts**

Use this value in the equation:

$$\text{Current (amperes)} = \frac{\text{Power (watts)}}{\text{Voltage (volts)}}$$

$$\frac{2390}{120} = 20 \text{ amperes}$$

Obviously, if all of these appliances are on at the same time, a 15-ampere circuit cannot carry this current. Even a single 20-ampere circuit would be taxed. As we have recommended, it is better to split the load between two, or even three, circuits.

Electrical Safety and Convenience

Safety is always a concern with electrical installations. Since darkrooms are at least half wet, consider ground fault interrupters for outlets or in the supply circuit on the processing side. Ground fault interruptors (GFIs) are very sensitive circuit breakers that compare the amperage flowing into a circuit (live or black wire) with the amperage leaving the circuit (neutral or white wire). If there is a difference of more than 0.005 ampere (meaning a grounded circuit), this device will cut off the power within 1/40 second and prevent injury to anyone who completes the faulty circuit. Although GFIs are relatively expensive, they should be given serious consideration. Because darkrooms combine both liquids and electricity, the extra safety provided by GFIs can be a valuable asset—just as it would be in the kitchen, bathroom, or laundry.

USEFUL HINTS

1. Install reset-type circuit breakers instead of replaceable fuses. Locate breakers close to the area served by the circuit.

2. Install constant-voltage transformers to minimize the effect of voltage fluctuations on enlarger lamps. Changes in the voltage cause corresponding changes in the color temperature of tungsten lamps; this in turn alters the color balance of color transparencies and prints. Therefore, maintenance of constant voltage in color work is essential.

3. Install at least five double outlets in a small darkroom. Locate them about 45 inches from the floor.

4. Place electrical outlets in the ceiling of a basement darkroom.

5. Do not locate electrical outlets in wet locations. An outlet too near a processing sink, for example, may be splashed with chemical solutions and water.

6. Use foot switches for convenience in enlarging; however, equip them with a cable long enough to enable the switch to be lifted out of harm's way if the floor is wet.

7. Ground all metal objects in a darkroom. Ask the electrician to take care of this in all places where it is necessary.

8. Use lamp sockets that include a switch for each darkroom lamp. You can then switch any lamp off independently of the others.

9. Control all processing-room circuits with a master switch located about 6 feet from the floor. However, make sure that refrigerators, freezers, and electric clocks are not affected by such an arrangement. Install the white-light switch just below the main switch; place the safelight switch below the other two, about 45 inches from the floor. Accidentally turning on white lights in a darkroom can be an expensive and embarrassing experience.

10. Install ground-fault-circuit interrupters.

ENVIRONMENT

In this era, people have become more sensitive to the environment. What about a darkroom? Traffic, for instance. Do small children in muddy boots tramp through the area you propose to use? Will the clothes dryer rumble, shake, and spew out lint while you are trying to print? Dust and dirt are the natural enemies of clean negatives and spotless prints. Making your darkroom lighttight will also minimize the intrusion of dust. When sealing for light, mois-

ture, and dust, cover basement cement walls with plastic roll sheeting before adding paneling. Wherever you construct your darkroom, you will want to insulate exterior walls. If the walls are in good condition, paneling might not be necessary and a good coat of paint may suffice. Caulking all joints in new construction (wall to ceiling, wall to wall, and wall to floor) as well as weather stripping around the door helps to accomplish the triple-purpose sealing.

Dust is the enemy of good photographic quality. Limit the intrusion of dust by taping or caulking seams in paneling. Coat cement surfaces with a good sealer.

A raw cement floor should be painted to keep down the dust. Apply one coat of paint formulated for use on concrete before construction begins so that all areas are covered, even under partitions. A second coat will cover all the digs and scratches you make during construction and while moving equipment into the room. Use resilient rubber mats or obtain remnants of self-padded carpeting to place over a cement floor. If you do not cover the whole floor, at least have mats in front of the enlarger and sink where you will be standing. Any extended length of time on a hard cement floor will be very tiring. Mats or pieces of rug can also be moved easily for swabbing down the floor.

Pay some attention to vibrations, too. Vibration destroys sharpness in prints made at long exposures or great magnifications. In a basement, check out furnace blowers, washers, and dryers. Can you feel the vibration? Does a glass of water on a solid support shake when the vibration starts? If so, move around until you're safe.

Ventilation is very important. Fumes from some photographic chemicals can be irritating to your eyes. The obvious answer is a fan or air conditioner that vents outside the house.

If mildew begins to appear on the walls, you really have a humidity challenge. At the first sign of mildew, consider a dehumidifier. Check for moisture seeping through basement walls. You may have to seal small cracks and paint the walls with a basement waterproofing paint. If you panel over outside walls, construct a vapor barrier with plastic sheeting. A dehumidifier for your darkroom will probably cost less than replacing your photographic equipment.

Heat or cold may be a problem in your darkroom. There are new efficient radiant heaters designed for

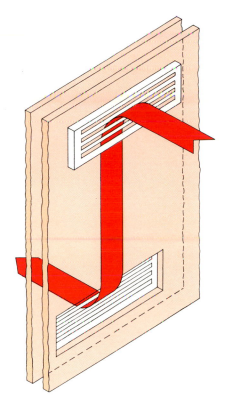

A lightproof ventilation chimney can provide an avenue for fresh air circulation in a small darkroom. The air in the darkroom will be static unless there is a pressure differential between the darkroom and the air on the opposite side of the partition. Direction of air flow will depend upon the adjustment of exhaust fan, air conditioner, or heat duct outlet.

darkrooms. An air conditioning unit may be mounted in a window before it is sealed to make the room light-tight. The air conditioner will replace a ventilating fan. See if you can duct hot or cold air from your heating plant into a basement darkroom. Although you may have a filter in your furnace, it is a good idea to install an auxiliary filter in the duct directed into your darkroom.

The volume of incoming air should be sufficient to change the air in a darkroom in about 8 minutes. The flow of air should be diffused or distributed so that objectionable drafts are not created. Apart from causing personal discomfort, drafts can cool tempered water baths and cause nonuniform drying of films or papers.

Provide suitably placed exhaust outlets to remove humid or heated air and chemical vapors. The air flow should be arranged so that hot air or vapors do not traverse the room but are immediately exhausted.

Temperatures between 65 and 75°F (18–24°C), coupled with a relative humidity between 45 and 50 percent, are compatible with photographic work generally. At the same time, these ranges provide comfortable working conditions for most people.

In small-scale black-and-white work, some deviation from these standards is acceptable. Many difficulties stem from lack of uniformity in both temperature and relative humidity. In color processing, accurate control of room temperature and relative humidity is essential.

A proper level of relative humidity is necessary in all photographic work. Excessive humidity is personally uncomfortable, and it has adverse effects on photographic materials. Insufficient humidity causes respiratory discomfort in people, static buildup on films and equipment, and curl and brittleness in photographic paper and finished prints. With low relative humidity, water evaporates rapidly from solutions in open trays, and static charges build up readily in the film. Such charges attract dust to the surfaces of the material and also cause discharge markings that often render an otherwise good negative unusable.

PLANNING SUMMARY

Here's a review of the various ideas you'll have to consider when you plan your darkroom.

1. Choose a location.
2. Design your space, allowing for equipment and facilities.
3. List and design any preconstruction changes or preparations, such as
 a. Relocating pipes, wires, or ductwork
 b. Sealing walls, floor, and windows
 c. Removing unneeded walls, shelves, or fixtures
4. Consider source, pressure, and supply of hot and cold water.
5. Test the cleanliness of your water.
6. Allow for drainage of water and chemicals.
7. Check for adequate supply of electricity.
8. Plan for extra circuits for your darkroom and consider the safety added with ground-fault interrupters.
9. Take a look at the overall environment.
 a. Traffic
 b. Dust
 c. Darkness
 d. Vibration
 e. Humidity
 f. Ventilation
 g. Heat or cooling
10. Check for necessary permits and inspections.
11. Make sure that hired mechanics are covered by insurance.

Building hints

Now the planning is almost over and you're ready to begin building. You'll notice that three lists of ideas follow. Read through these lists—construction, electrical, and plumbing—for tips that might save you time, money, or aggravation.

Careful shopping for materials can pay dividends in savings. Look for close-out seconds in paneling and cabinets.

CONSTRUCTION IDEAS

1. Buy seconds or close-outs of prefinished paneling for your walls. Dry wall may be less expensive but requires seam taping, filling, and painting. If you've ever tried to hang anything on dry wall, you'll appreciate the convenience of paneling. If you plan to insulate the walls, check local building codes for paneling requirements.

2. If you are building into a corner or closing off the end of a room, consider making the partitions removable by bolting them together from the outside. It will help keep a landlord happy or it might help sell your home to someone who has no need for a darkroom.

3. Furniture
 a. For workbenches or sink supports, buy seconds in kitchen cabinets and plastic laminate counter tops. Maybe you can combine the darkroom with kitchen remodeling and use discarded cabinets from the old kitchen. Be sure the enlarger bench top is deep enough. Some enlargers have baseboards longer than the 23- or 24-inch depth of the standard kitchen counter top. (We made our own from a piece of particle board covered with plastic laminate.)
 b. You can also construct benches and sink supports from ¾-inch plywood or particle board and 2 x 2s or 2 x 4s. Paint the supports with epoxy or chemical-resistant paint. If you're designing and building the benches, make them different heights according to their intended functions. A film-loading bench should be taller than an enlarger bench, which in turn should be taller than a trimmer bench. How about a sliding, swinging, or dropping shelf for your trimmer, which after use will disappear under a bench or shelf or hang against the wall.
 c. Set bench and sink heights to accommodate your own body height.
 d. Use pieces of tapered wood shingles as wedges to level all benches and to pitch sinks and processors for drainage.

4. If you are building a new house and plan a darkroom in the basement, an extra course of cement blocks in the foundation will be a wise investment. The extra height thus provided in shop, laundry, other work areas, and a possible family room can justify the additional cost.

5. Most basements, particularly older ones, are notoriously out of square. Every joint, angle, and measurement should be triple checked before cutting structural materials. You'll probably need patience to obtain smooth fitting elements.

6. Since none of your construction will include load-bearing walls, it may be acceptable to stud with 2 x 2s rather than 2 x 4s. Any wall with a prefabricated door and frame, however, will require standard 2 x 4 thickness.

7. Plan carefully the sequence of building steps to make the job go as smoothly, quickly, and economically as possible.

ELECTRICAL INSTALLATION

1. Install at least two circuits in your darkroom—one circuit for printing and processing equipment and one for general room illumination, safelights, and accessories. A separate circuit for your printing equipment is necessary if you want consistency in your print exposures and color balance. Also, a processor motor that runs at different speeds depending on circuit loading can easily disturb the development and color balance of your film or prints.

2. In a basement, placing some outlets in the ceiling may be convenient, especially if you base your walls on 1 x 2- or 2 x 2-inch furring strips. Standard electrical boxes will be too deep to fit into the walls. Special, shallow boxes are expensive. An alternative is to use surface mounted wiring with correctly installed ducts for the wires. Such wiring requires either snap-together U-shaped ducts or screw-together tube ducts and accessories. Check with an electrical supply firm for the varieties available. As with all other electrical installations, make sure these ducts are safe for your installation and conform to your local code.

3. Recess lighting fixture and safelights in the ceiling for more headroom. Older fluorescent lamps retain an "afterglow" that can fog film several minutes after the lamps are switched off. While this effect has been eliminated with modern lamps, many lab workers prefer to have tungsten lamps just to be on the safe side.

4. How about a small, low-voltage, spotlight mounted in the ceiling over the hypo tray to serve as an inspection light? An isolated, low-voltage circuit (6 or 12 volts) can reduce electrical shock hazard. Activate this inspection light with a pull string, a foot switch, or a knee switch.

5. For results you can count on, with standard negatives and carefully kept color printing notes, enlarger-lamp output stability is very important. When the voltage fluctuates, so does the color quality and the intensity of the lamp. For color printing and especially if darkroom circuits are shared with other rooms, install a

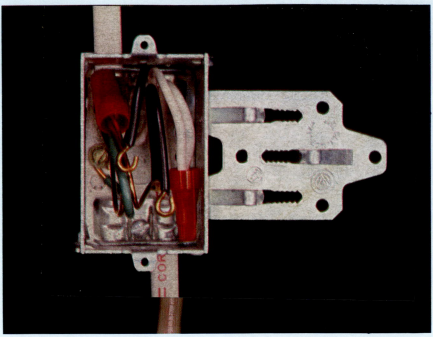

constant-voltage transformer between the timer and the enlarger. Many enlarger manufacturers offer them as accessories. You may also use a variable transformer set at 90 or 100 volts. This will stabilize the enlarger lamp at a lower voltage than normally supplied by the house circuit. If the voltage in the house circuit drops five or ten volts during times of peak demand, such as, dinner time during the winter or hot spells in the summer, your enlarger lamp will be operating consistently at a voltage below the drop level, therefore intensity and color output will not change. You will notice that with the voltage reduction method, the decreased blue content of the light will require less red-yellow filtration for color negatives and more cyan filtration for printing color transparencies on reversal paper.

6. Install about 50 percent more outlets than you think you'll need. In the end your darkroom will be neater and more convenient.

7. Review the ideas listed in the section on *Electrical Safety and Convenience*.

8. Perform the following safelight test before permanently locating safelight fixtures. Remember that safelight filters need to be accessible for periodic replacement.

Safelight Test: An easy safelight test consists of exposing a small piece of your usual enlarging paper with the enlarger light just long enough to create an even, very pale gray tone when the paper is processed normally. You'll probably have to close the enlarger lens to its smallest opening and use a very short exposure time. When you have determined the proper exposure experimentally, expose (flash) a piece of paper at those settings; then place a coin on the center of it. Leave the coin and paper beneath the enlarger for 5 minutes, *with the safelight on and the enlarger light off*. Process the paper normally. The processed sheet should look the same as the one processed immediately following exposure. If you can spot even a faint outline of the coin, the safelight isn't safe.

If all is well in the enlarger area, repeat the test by placing flashed paper and a coin in the processing area for 5 minutes, preferably just above the developer tray. If no image of the coin materializes, the safelight is adequately safe.

PLUMBING INSTALLATION

1. Check the pressure and cleanliness of your water supply and the capacity of your hot water tank. This is particularly important if you are processing color materials.

2. Install a water filter in the main cold water line to filter both hot and cold water if tests confirm the need for such an installation.

3. Tap into the cold water line as close as possible after the water filter.

4. Place shut-off valves in both hot- and cold-water lines as they enter the darkroom so the room can be completely isolated.

5. Hook up all sinks, processors, and faucets or taps with unions to facilitate removal or repair of equipment.

6. Run water lines and drains on the wall surface—not inside a partition. They are easier to repair or change when exposed.

7. If installing a temperature control valve, provide separate hot and cold water taps as well.

8. A mixing tap with an in-line thermometer is more economical than a temperature control valve and may be perfectly adequate for your needs, especially for black-and-white work.

9. Possible waste water disposal: In the basement, tap into the laundry tub drain. Or, replace the cap on a basement drain clean-out with a cap threaded for a 1½-inch drain-pipe adapter. Screw an adapter into this threaded cover, provide a trap, and hook up your sink or processor to this trap. Or, run your drain into a sump or holding tank and pump your waste water into a septic tank, dry well, or sanitary sewer. Check to make sure you don't violate any codes. Clarify the sewer situation in your neighborhood with your Department of Public Works, Pure Water Authority, or Sewer Department. You may have to contact more than one of these offices to get an answer. Be patient—eventually the right person will give you the information that you need.

10. Some sink ideas: To go first class, buy a prefabricated stainless steel or fiber-glass sink with built-in water temperature control, backsplash, and a storage shelf or cabinet. (Rather expensive, even without the options.) Purchase a fiber-glass or plastic sink and build the support with a shelf or a cabinet for storage. Build sink and supports from ¾-inch marine plywood and 2 x 4s and paint with epoxy or line with fiberglass.

Project darkroom

As you now begin to have definite thoughts about your future darkroom, we will begin to plan ours. We'll follow many of the steps suggested by the preceding text. This first phase includes choice of location and design.

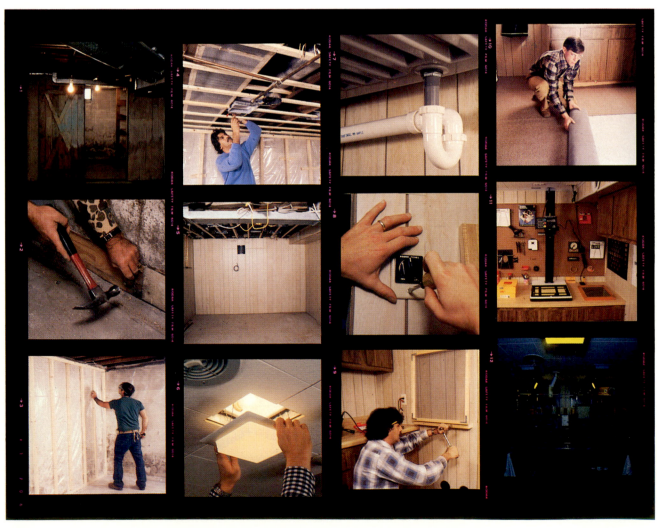

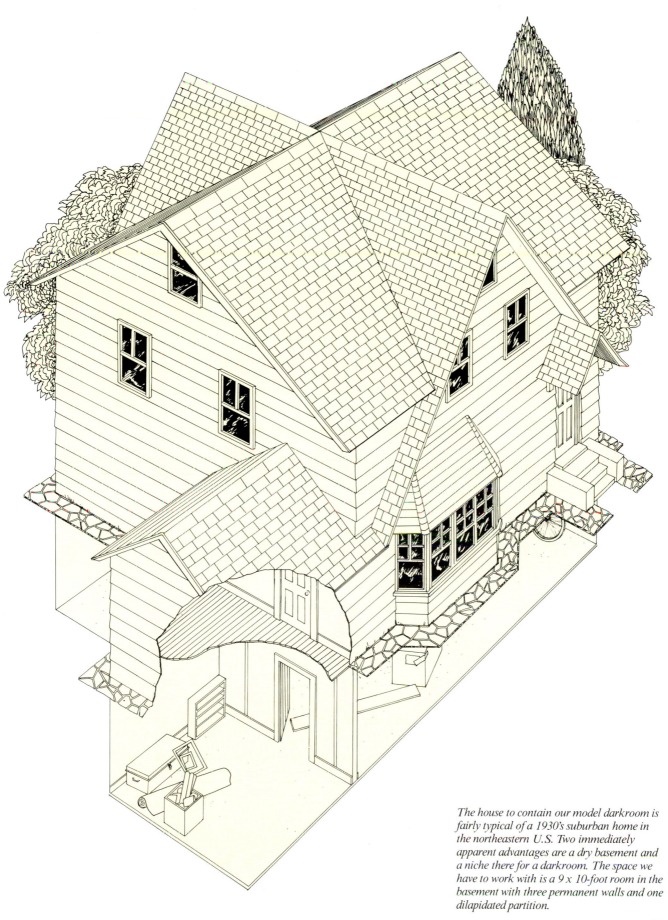

The house to contain our model darkroom is fairly typical of a 1930's suburban home in the northeastern U.S. Two immediately apparent advantages are a dry basement and a niche there for a darkroom. The space we have to work with is a 9 x 10-foot room in the basement with three permanent walls and one dilapidated partition.

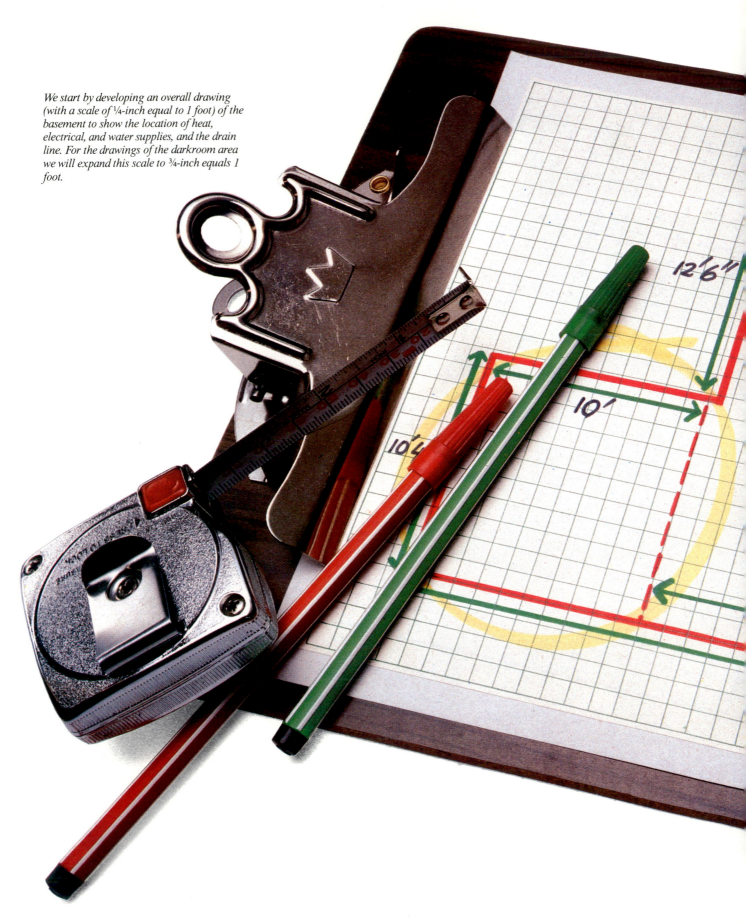

We start by developing an overall drawing (with a scale of ¼-inch equal to 1 foot) of the basement to show the location of heat, electrical, and water supplies, and the drain line. For the drawings of the darkroom area we will expand this scale to ¾-inch equals 1 foot.

REARRANGING

Two heating/air conditioning ducts hang below the joists in the middle of the room. To make a uniform, uninterrupted ceiling, these ducts have to be moved to run along one wall so they can be boxed in and placed up between the joists above the ceiling.

The rather permanent location of a cold-air return to the furnace (interlaced with some main electrical lines as well) determines the placement of a new, solid partition with door—roughly the same as the old partition.

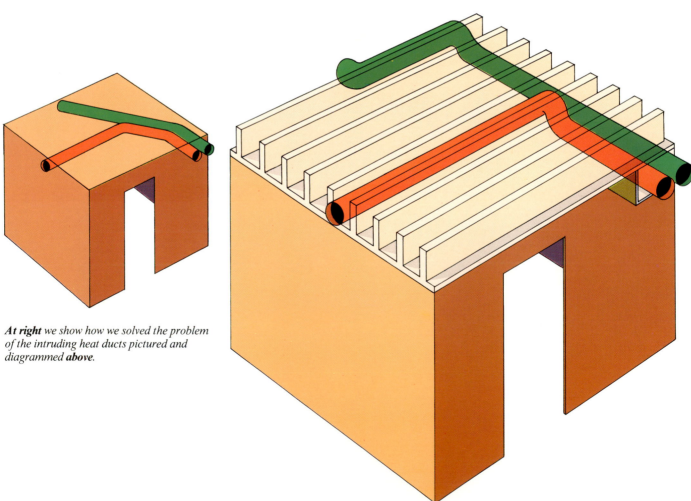

At right we show how we solved the problem of the intruding heat ducts pictured and diagrammed *above*.

The old partition, **left**, was in poor condition with the opening in an inconvenient location. It was just as easy to tear the partition out to relocate the door and to provide access for our other renovation plans. The new partition ended up as you see **below**.

When we have on paper the location of permanent objects in this room we can proceed to plan the location of our equipment. Having to design our darkroom in a confined space, we produced some different equipment arrangements. (See pages 22-23). Here is the final layout on paper. We like this one particularly well because it is relatively simple, provides excellent separation between wet and dry areas, and affords enough space for movement and storage. Naturally, the work-flow pattern is good and the various fixtures are located in such a way as to make facilities hookups fairly easy.

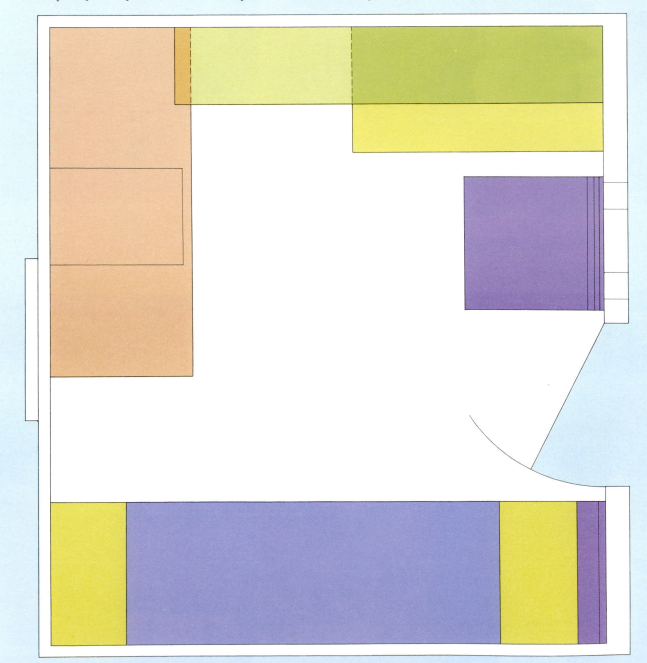

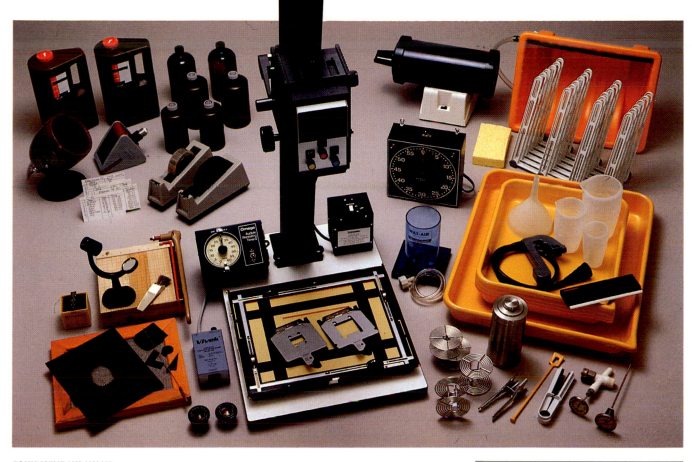

EQUIPMENT WE WANT
Wet Side

Sink[1]

Trays—4—11 x 14-inch, 1—16 x 20-inch[2,4]

Processing tube and roller[2]

Water-temperature monitor

Thermometer[4]

Film processing tank and reels[4]

Film washer[2,4]

Print washer[2]

Print drying rack[3]

Film drying line[3]

Film magazine opener[3]

Chemical mixer[4]

Film sponges[4]

Funnels[4] & Graduates[4]

Squeegee board[3]

Processing timer[4]

Water filter

Squeegee[4]

Tray siphon

Dry Side

Enlarger[2]

Negative carriers—35 mm, 6 x 7 cm[3]

Lenses—50 mm, 90 mm[3]

Voltage regulator[2]

Paper easel[2]

Printing timer[3]

Contact print frame[4]

Paper trimmer[2]

Static brush[4]

Enlarging magnifier[4]

Dodgers[4]

Vignetters[4]

Dark drawer

Miscellaneous Equipment

Safelights— 1-10 x 12-inch lamp and 2-
 KODAK 2-Way Safelamps

Exhaust fan (installed in window)

Passive lighttight ventilators

Speakers[3]

Trash can[4]

Rug

Tape—black photographic, masking,
 and clear [3]

Instruction cards—for different
 processes [3]

Bottles—2—1-gallon white plastic for
 negative and print fixer[4]

2—1-gallon brown glass for warm and
 cold tone paper developers[4]

6—1-quart brown glass for negative
 developers and replenisher[4]

Several—1-gallon and 1-quart bottles
 for color chemicals (glass for the
 developers and plastic for the others)[4]

[1]Requires floor space.

[2]Requires counter space.

[3]Requires counter, wall, or storage
 space. Be sure to give adequate
 working room when measuring counter
 space, and remember—counter space
 usually means floor space.

[4]Requires storage, shelf, or counter
 space.

PREPARING FOR CONSTRUCTION

Once the planning is over, we will look into some of the preconstruction preparing we'll have to do. This includes work on the floor, plumbing, heating and air conditioning, and the supply of electricity.

We first decide to level the uneven, chewed-up floor with a layer of ready-mix concrete to simplify later installations of the partition, sink,

and workbenches. The floor is so bad that leveling the workbenches would require shims as thick as a 2 x 4 block.

Before pouring the concrete, we place pieces of the old partition on edge in the joint between the floor and the three exterior walls to form a channel.

When leveled off, the new layer of concrete on the floor varies from one

to three inches in thickness.

After the concrete dries, we remove the boards to leave a channel for any moisture (sweating or leakage) that may accumulate on walls.

Coating the fresh concrete floor with sealer will eliminate any dusting from later wear. Old, completely cured concrete can be painted instead.

*Although the floor is dry, we find, **right**, that the concrete is rough and uneven. Deciding that we should add a layer of concrete to even out the floor, we are providing for a drip channel at the edge of the room by temporarily nailing scrap lumber along the three exterior walls, **below**.*

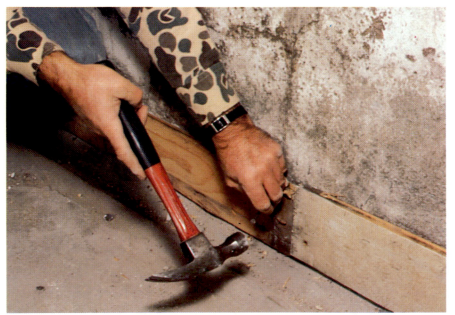

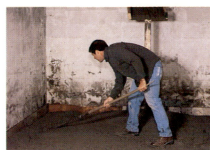

As the cement is poured, we rake and distribute it to eliminate voids and to work it up to the edge boards.

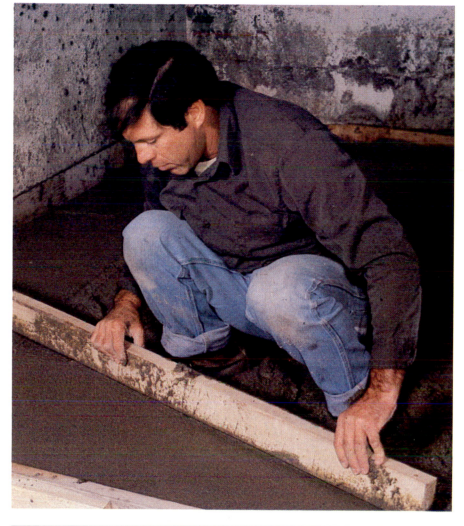

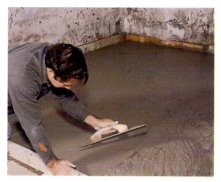

A straight 2 x 4 serves as a screed for evening the concrete surface. A steel tool provides the final finish.

As the concrete sets up, we remove the temporary edging board to form a channel around the perimeter wall. When the concrete has cured as recommended, we will coat the floor with a sealer.

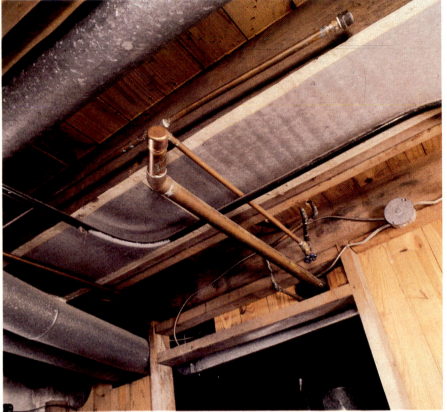

As we reconstruct the water lines, we are adding a filter to the supply line.

Overhead pipes are in the wrong place and cannot provide a drain.

Pipes

We have to replace the plumbing in this room. The water is in the wrong place and the immediately accessible drain is in the ceiling—we cannot make the waste water flow uphill.

Placing a water filter in the main cold-water line where it enters the outside wall cleans all the water in the building. You may want to filter water entering the darkroom only or to have a final filter right on the faucet or tap.

Flushing the hot water tank periodically promotes the cleanliness of all water entering the darkroom. Depending on the age and condition of your water heater, you may want to do this too or you may wish to leave well enough alone.

We intend to drain our processing effluent into the main sanitary sewer of the house by replacing the cover of a clean-out opening with a new cover that will accept 1½-inch drain pipe.

The clean-out cover will provide the drain opening that we need to serve our darkroom.

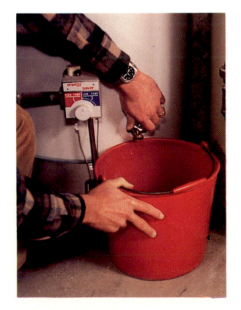

We are draining a bucket of water from the bottom of the hot water tank to check its condition. Periodic draining will remove sediment and rust from the tank.

Wiring

The original wiring was old-fashioned, inadequate, confusing, and possibly unsafe. Fortunately, the new owner of the building has had his electrician install a new main panel box to supply the rest of the building. We can run a supply line from the spacious main panel to a new sub-panel box with its own shutoff switch. Now we can shut off all the electric service when the darkroom is not in use.

We are using circuit breakers with ground-fault interrupters in the new subpanel box.

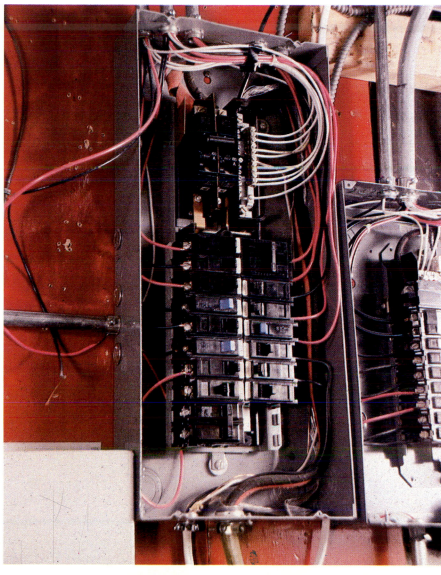

The main distribution panel serves the entire house. It constitutes an updating of an older system.

To supply our darkroom, we have installed a separate panel box with its own shutoff switch.

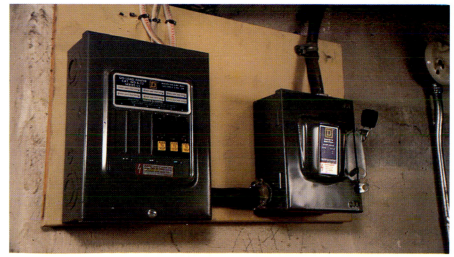

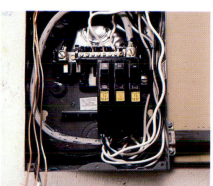

Inside the panel box for the darkroom are three circuit breakers for the three separate darkroom circuits. Each circuit breaker has a built-in ground fault interrupter.

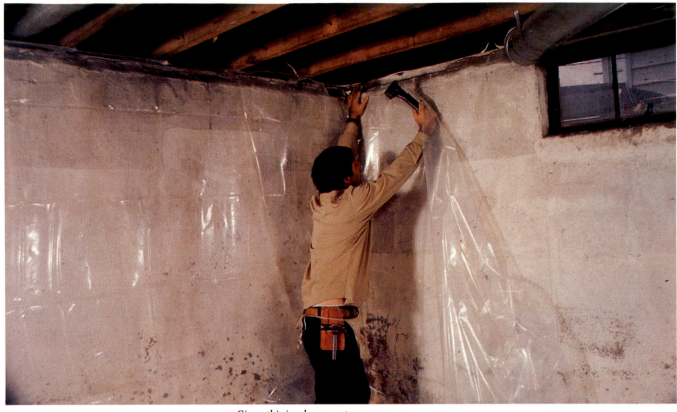

ROUGH CONSTRUCTION

The rest of this book relates in words and pictures just how we built our darkroom. We have already shown what we did to prepare the area for basic construction—pouring a new floor, moving heating ducts, and removing the old partition, electric wires, and plumbing lines. This is how we will start our rough construction.

First we cover the three existing outside walls with roll plastic sheeting and then fur them out with 2 x 2-inch lumber, 16 inches on-center. The furring strips will support the prefinished paneling we plan to use to cover the walls. (This is all standard building practice.) Some of the strips, incidentally, have to be shimmed out from the old concrete because the existing walls aren't true.

Since this is a basement room, we are providing a vapor barrier of plastic sheeting to minimize any moisture problem.

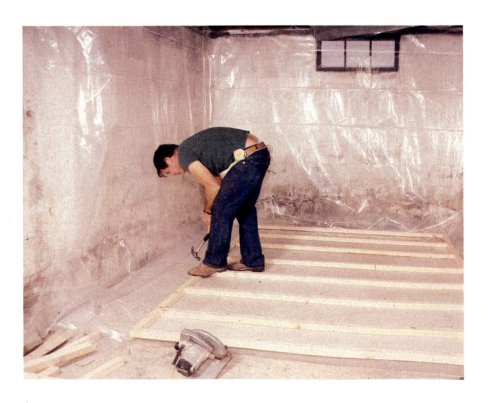

The easiest way to construct the wall furring is to assemble the 2 x 2s on the floor and then raise the whole wall unit into place.

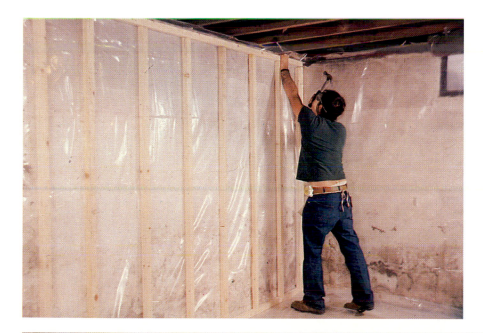

Final step in erecting the 2 x 2 framing is to make it plumb (using shims to space it from the wall as needed) and to nail it into place. Each of the three exterior walls gets this treatment.

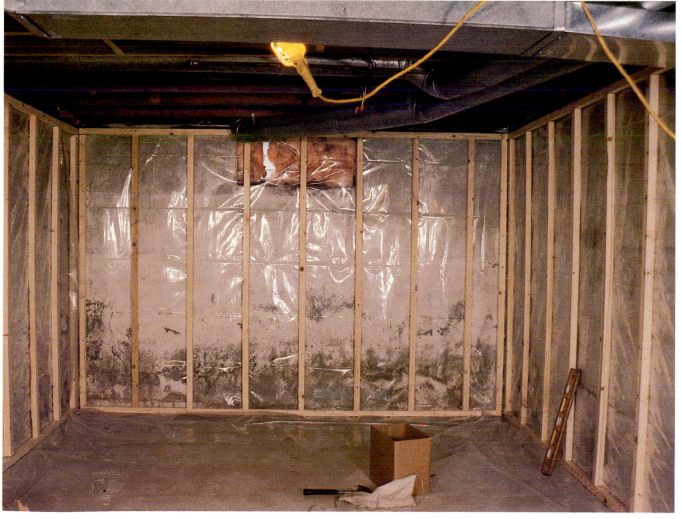

Air

We're able to capitalize on the existing central heating and air conditioning system. When we moved the distribution pipes from the center of the room to the side, we installed outlets to dispense conditioned air into the darkroom, also providing for air filters at the outlets. At this time we won't build the new partition for the end wall—just install the header and sole plate. The partition would obstruct our photography of construction progress. The partition will be finished after the equipment has been moved into the room and located along the other three walls.

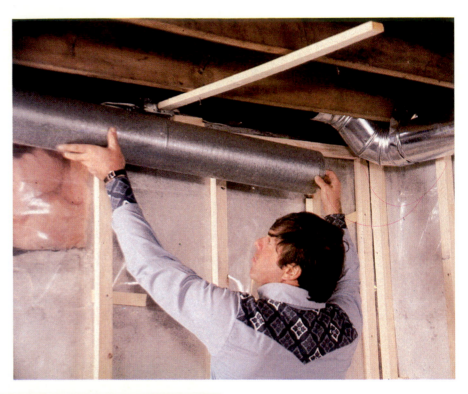

Rerouting of the conventional heating duct is going to give us a lot more headroom. Assembly of the new ducts is straightforward, requiring only sheet metal screws. We make sure that the heat outlet is properly located before boxing in the duct work along the side of the darkroom.

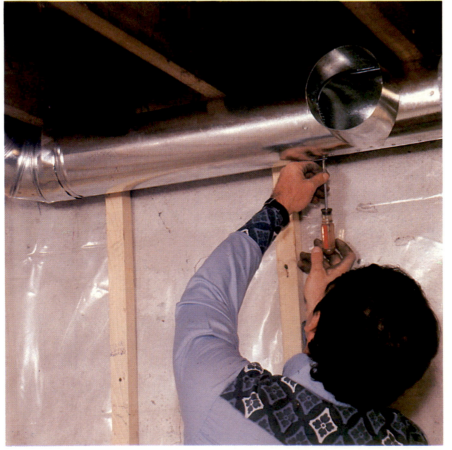

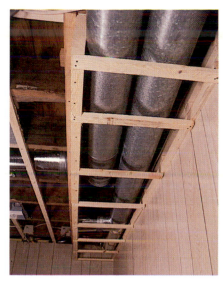

Boxing in the ducts proceeds with the use of filler strips as needed.

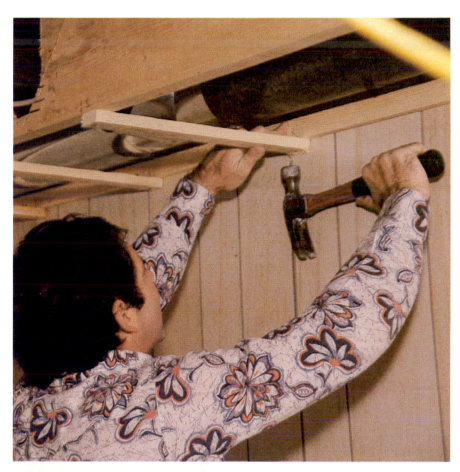

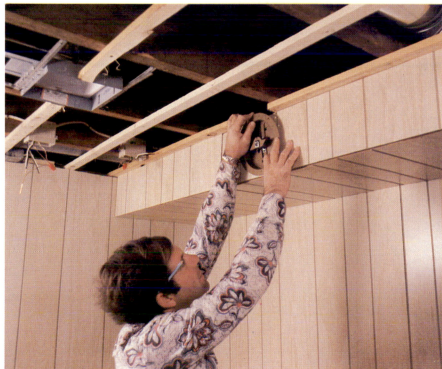

With the boxing in of the ducts completed, we refit the heat outlet and louvered finishing cap.

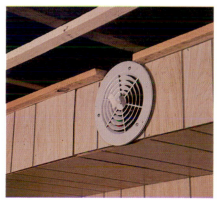

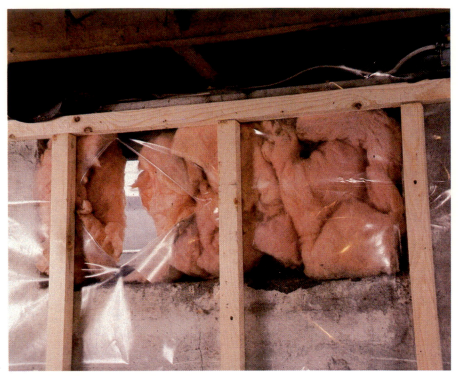

Since we are sealing up the existing basement window, we are installing an exhaust fan as we proceed. We have insulated the opening, taking care to keep the fan and exhaust duct clear. The finished unit has a decorative cap that excludes all light.

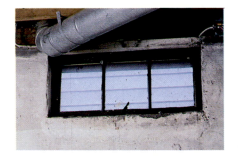

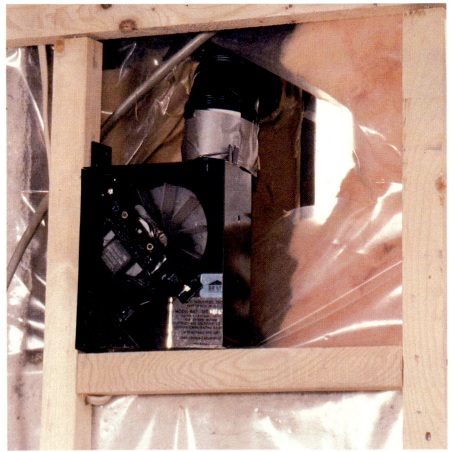

Ceiling

Next we run 1 x 2-inch furring strips 12 inches on-center across the ceiling joists. This will provide support for the ceiling tiles.

We just went through a lot of the work rather quickly, but it is all basic carpentry—nothing tricky and no real surprises. The list that follows includes the construction materials we have already used. You may find some ideas here that will help you in buying your own materials. The list obviously includes some items we won't touch until later.

With furring complete and duct work boxed in, the only remaining rough construction work is furring for ceiling tile. We are using 1 x 2 furring on 12-inch centers.

CONSTRUCTION SUPPLIES

Concrete for floor (approximately 1 cubic yard)

1 gallon of concrete sealer

Lumber (all #2 common pine or fir):
28 pieces of 2 x 2-inch x 8-foot
6 pieces of 2 x 2-inch x 12-foot
12 pieces of 1 x 2-inch x 10-foot
4 pieces of 2 x 4-inch x 10-foot
12 pieces of 2 x 4-inch x 8-foot
2 pieces of 2 x 8-inch x 10-foot

100 square feet of ceiling tile (white)

1 sheet of 4 x 8-foot perforated fiberboard

2 sheets of 4 x 8-foot x ½-inch plywood (good on two sides)

4 sheets of 4 x 8-foot x ¾-inch plywood (good on two sides)

1 sheet of 4 x 8 x ¾-inch particle board for counter tops

1 sheet of 4 x 8-foot plastic laminate

2 sheets of 4 x 8-foot x ⅛-inch tempered pressboard

1 roll polyethylene sheeting (10 x 25 feet)

1 36-inch prehung door with trim and hardware in 4½-inch jamb

1 tube of caulking compound

13 sheets of 4 x 8-foot prefinished paneling

1 pound of light-color paneling nails

80 feet of plastic moulding to match the paneling

1 quart of contact cement

1 disposable paint roller and tray for applying the contact cement

1 pint carpenter's glue

Nails:
5 pounds of #8 concrete
15 pounds of #10 spikes
10 pounds of #8 common
5 pounds of #6 common
5 pounds of #4 common
1 pound of #6 finishing
1 pound of #4 finishing

ELECTRICAL INSTALLATION

Now let's consider roughing in the electric and plumbing services. We will cover these procedures with a little more detail. We aren't changing any basic practices but we are doing some things a bit differently from normal house construction technique.

We are running three circuits from our new subpanel—one each for the dry side and the wet side, and a utility circuit for everything else (lights, safelights, and fan).

You will notice on this incomplete drawing of the south wall that we have two switch plates. The upper one at six feet contains two switches—one controlling the white lights over the wet area and the other controlling the white lights over the dry side. The lower set of switches at 45 inches controls the safelights—one, the safelights over the sink and the other, the safelight in the center of the room.

It's obvious why we are separating the room- and safelight switches. Setting the roomlight switch high on the wall may prevent accidentally switching the wrong light on. But why break the safelights into two switches? It may be helpful to lower overall safelight illumination when focusing an accidentally overexposed negative.

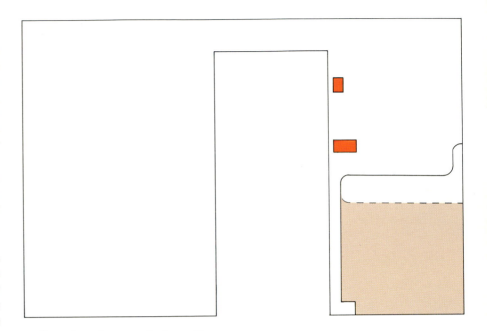

Wall switches adjacent to the door will control the darkroom circuits. Note that the white light switches are placed at the six foot level to reduce the possibility of inadvertently tripping the wrong switch in the dark.

Shown schematically are the switched circuits in our darkroom. White lights are controlled from the upper switches, safelights from switches at the lower level.

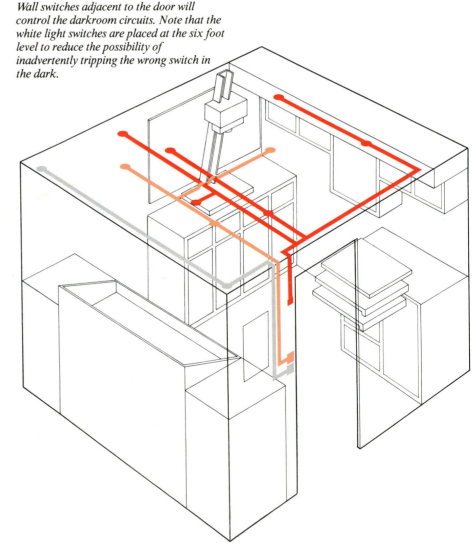

*The four recessed ceiling lights, located as shown at the **lower right**, provide uniform overall incandescent white light.*

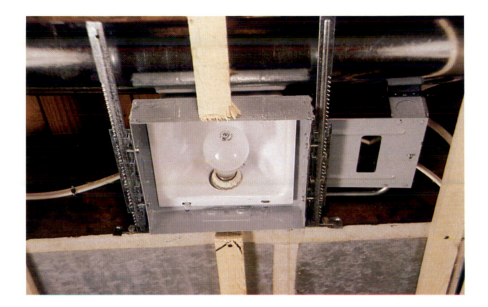

If you regularly perform different darkroom operations, you may want different filters in the different safelight fixtures. A typical division would be KODAK Safelight OC Filters over the sink for black-and-white printing and a KODAK Safelight Filter No. 13 in the center safelight for making color prints.

Always follow the directions for the distances of fixtures from the work areas and the sizes of the lamps. Safelights are not safe if they are too bright and too close to the sensitized material you are using. It's helpful to test their safety on a regular basis. This could be every month, or every three months, but surely every six months. See page 36 for a simple, but effective, safelight test.

For overall white light illumination we have chosen drop opal ceiling lights. They have the capacity for 100-watt lamps and the opalized plastic diffusers extend down from the ceiling about 2½ inches. Four of these lights provide an even, high light level for this size room.

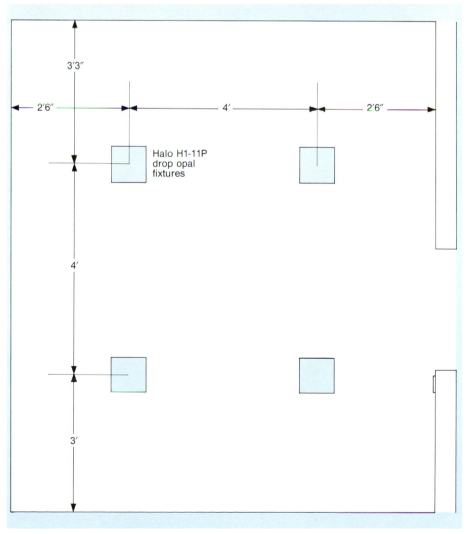

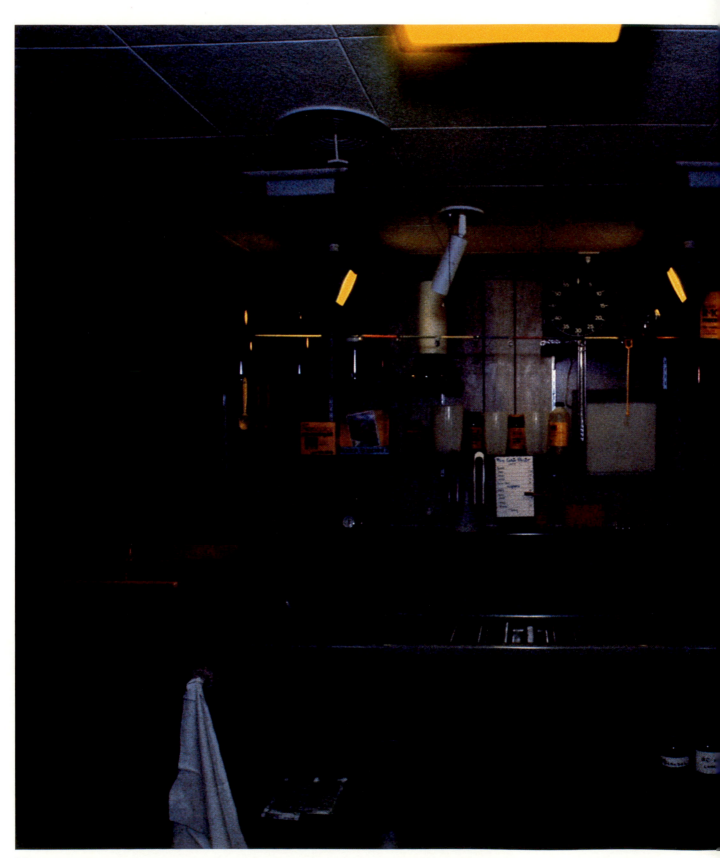

Safelights

For safelights we have chosen three Kodak units. General illumination from the center of the room is supplied by a 10 x 12-inch KODAK Utility Safelight Lamp, Model D, recessed in the ceiling to avoid bumping our heads.

Over the sink located one third the long distance from the side walls and 18 inches from the back wall are two KODAK 2-Way Safelamps. Each lamp contains two filters that allow the light patterns from these lamps to cross over the sink work area and light the workbenches on either side of the sink.

This diagram shows the location of safelights installed in our darkroom.

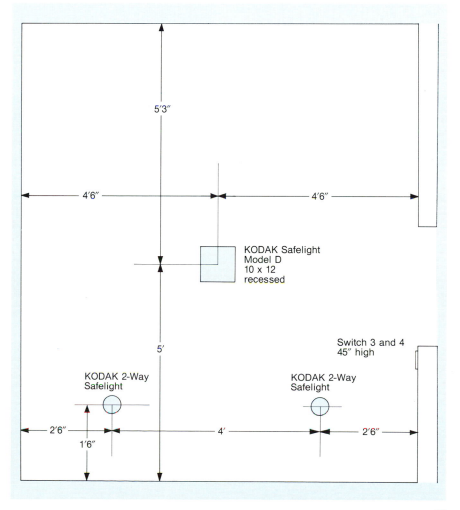

5'3"

4'6" 4'6"

KODAK Safelight
Model D
10 x 12
recessed

5'

Switch 3 and 4
45" high

KODAK 2-Way
Safelight

KODAK 2-Way
Safelight

2'6" 4' 2'6"

1'6"

Inspection Light

Over the left side of the sink we are installing a low-voltage inspection light for viewing prints in the hypo or wash tray. With this light over the hypo tray, we won't have to leave the sink to turn on white light—the drop cord is directly overhead. Wet hands, moreover, do not mix well with electricity. There's obvious danger, and in time hypo on our hands could corrode a wall switch, the switch plate, and everything else around it.

To control spill light, we are using a low-voltage spotlight in a tubular fixture. We have drilled a hole in the mounting plate of this fixture to install a string-actuated switch. A foot switch or knee switch could be used but would require more wire and be more prone to accidental activation.

On the same circuit as the lights we are putting a switch for the exhaust fan.

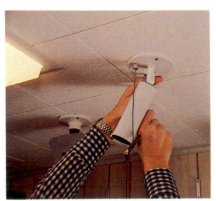

*The low-voltage inspection lamp requires a transformer, shown installed against an electrical junction box in the ceiling (**left above**). The lamp must be adjusted carefully so that it will shine into the hypo or wash tray. Stray light that might fog uncovered paper should be avoided.*

Separate Circuits

The electrical circuit on the wet side of the room will supply timers, processor motors, negative illuminator for inspecting wet negatives, tray heaters, and any other appliance that is used in the wet side of a darkroom.

The second circuit is for the dry side of the room and will supply the enlarger, its timer, and voltage stabilizer. This arrangement should control precisely the quality and intensity of the enlarger lamp output.

We are mounting the outlet boxes supplying electricity to the wet and dry sides of the room in the ceiling. We find it more convenient to plug in above rather than behind other equipment on the walls, and ceiling mounted electrical boxes also keep the walls clear for shelves and pegboard.

The ceiling location also allows us to use standard 3½-inch-deep electrical boxes instead of special-order 2-inch-deep boxes to fit our furred-out walls. In some areas of the country the electrical code will allow you to run only one supply wire into an undersize (shallow) box. Since these units do not permit an exit wire, you cannot tie three or four boxes together into a single circuit.

A convenience outlet is mounted on the south wall next to the utility bench and tied into the wet-side circuit. Our electric code requires an outlet within 48 inches of a work area. We also can't use the lighting circuit. This outlet can supply an illuminator for sorting negatives or can be used to power a vacuum cleaner or other appliance.

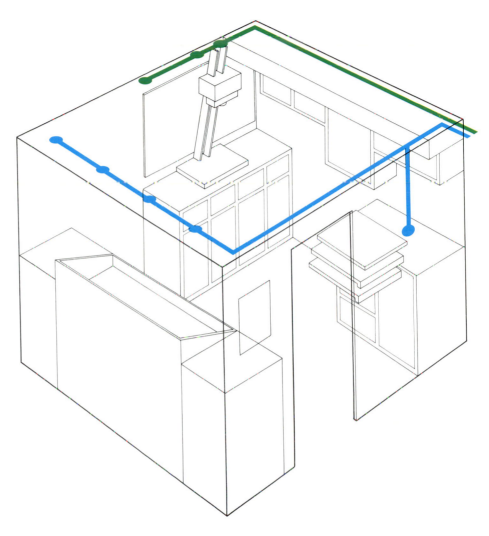

*The electric circuits serving outlets in the ceiling are shown **above right**. We find that outlets in the ceiling are convenient for keeping cords out of the way and allow us to use standard electrical boxes, **right**.*

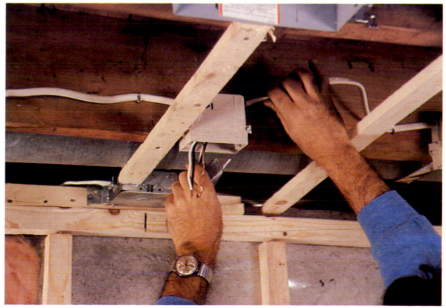

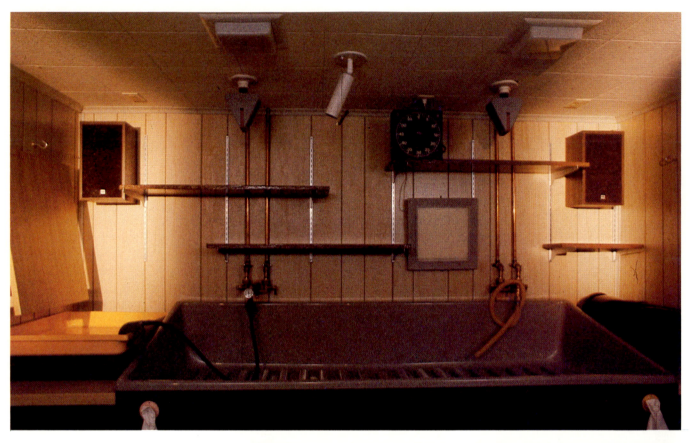

Sound System

Comfort while working in the dark is one of our prime considerations. One of the first things we designed into this room was a sound system. Instead of listening to a portable radio, we are tapping into the remote speaker terminals of our stereo amplifier. We are leading wires to a stereo volume control and from that to phono jacks mounted in the corners of the long wall over the sink. We can then attach ¼-inch phono plugs to two small bookcase speakers that hang on the walls near the ceiling. We can now enjoy our music at any volume we want. You may want a radio, a complete, self-contained sound system, or a combination system with an intercom to the rest of the house.

Speakers for our sound system, located at either end of the sink, are controlled by a conveniently located volume control. The speakers are plugged into the jacks that we had wired in when the walls were open.

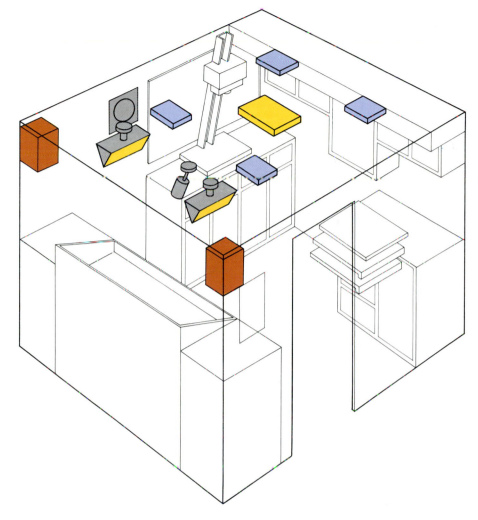

This drawing of our complete electrical plan shows location of the various fixtures. It may help you when you locate the electrical service and fixtures in your darkroom.

ELECTRICAL SUPPLIES

30 feet of 100-ampere subfeed cable, 3-wire with ground

1 3-place sub-panel box (Square-D 006-12S*)

1 60-ampere disconnect (Square-D DU 322*)

3 20-ampere ground-fault interruptors to fit above box (Q0120GFI*)

1 100-foot coil #12 wire, nonmetallic sheathed cable, 2-wire with ground

4 100-watt Halo H1-11P drop opal ceiling lights*

4 100-watt bulbs

2 7½-watt bulbs

1 15-watt bulb

2 porcelain ceiling receptacles (Leviton 49875*)

3 4-inch octagonal boxes

20 3 x 2-inch switch boxes

1 4-inch square box

2 double switches: single-pole, single-throw

1 single-pole single-throw switch

12 tight-grip duplex outlets for ceiling mounting

1 4-inch square double duplex outlet cover plate

20 duplex 3 x 4-inch cover plates

1 60-ampere circuit breaker for main panel to control sub-feed

1 lamp fixture (Halo H6522*)

1 transformer (Halo H6591*)

1 12-volt lamp (Halo Z-1*)

1 SPST pull-chain switch (McGill #21*)

1 box of 100 cable staples for #12 wire

25 2-hole cable straps

1 box of 100 Wire-Nuts HS-21*

1 box of 100 Wire-Nuts HS-18*

1 roll of ¾-inch plastic electrical tape

1 stereo volume control (Radio Shack #40-979*)

2 ¼-inch phono jacks

2 ¼-inch phono plugs

1 100-foot roll of two-conductor speaker wire

*Naturally, there are equivalent products from other manufacturers.

PLUMBING

As with the rest of our darkroom construction, the plumbing will be installed according to basic practices, but we will add some variations.

The drawing shows how little plumbing we have to do. You've already seen how we fitted the water filter into the cold-water line for clean water throughout the building.

We also added in-line valves to both hot and cold water pipes just before they enter the room so that all water lines to the room can be shut off when not in use.

The first step toward successful waste drainage is to replace the cover on a floor clean-out port with a new rubber adapter for 1½-inch drain pipe. A 1½-inch PVC adapter fits into the rubber adapter.

A 2-inch piece of ridged PVC pipe cemented to the adapter will accommodate the next item.

Because the clean-out sets in the floor at an angle, we have to add a Y-fitting to the PVC pipe to bring it into a better line and also to retain its use as a clean-out.

Some more PVC pipe, several elbows, and a P-trap lead the drain along the wall to the darkroom. A union in this drain line allows it to be disconnected so the new clean-out cover can be removed if it is ever necessary.

With installation of the water filter and shutoff valves, our connections outside the darkroom for the water supply are complete.

After removing the cleanout cover from the drain, we installed a rubber adapter that will accept 1½-inch PVC drain pipe (below). Use of a Y-fitting allows us to install our drain and still retain the clean-out should it be needed (right). A trap under the sink and a length of PVC pipe complete our drain connection.

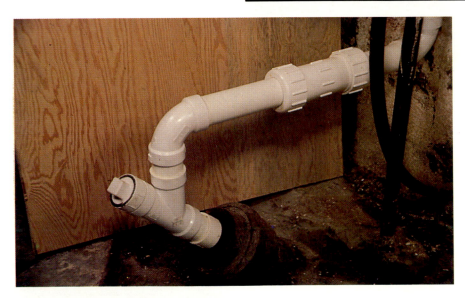

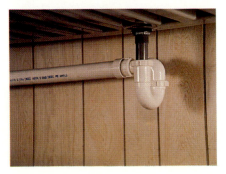

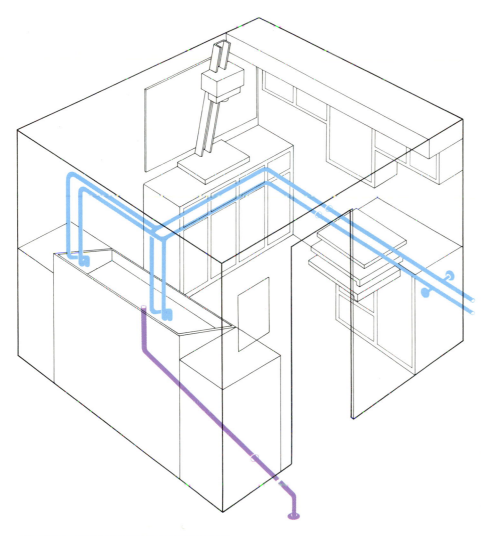

PLUMBING SUPPLIES

25 feet of 1½-inch PVC drain pipe

1 PVC 1½-inch P-trap with clean-out

3 1½-inch PVC 90° elbows

1 1½-inch Y-fitting

1 3-inch rubber clean-out cover for 1½-inch drain pipe

1 1½-inch PVC adapter from clean-out cover to ridged PVC

1 1½-inch PVC union

2 ½-inch brass in-line shutoff valves

40 feet of ½-inch copper water pipe, class-M

10 ½-inch copper elbows

2 ½-inch brass couplings

1 brass laundry tub faucet

4 ½-inch brass drop-ear elbows

4 ½-inch brass nipples

4 ½-inch brass street elbows

1 can PVC cement

1 cylinder of propane for torch

1 roll of solder

1 can of solder flux or 1 small jar of instant solder

1 sheet of emery cloth—fine grit

1 water filter (Oscar Fisher*)

2 ½-inch brass unions

1 line temperature monitor with thermometer (Flo-Temp*)

1 snap-on hose connector

1 piece of ½-inch by 24-inch surgical hose with female hose connector attached

*Similar products are available from other manufacturers.

Our plumber is an expert at soldering copper pipe with roll solder and flux. If you prefer, you can use instant solder that comes in paste form with the flux mixed in. It's more expensive but it is easier to work with.

FINISHING UP

Now we are approaching the end of the job. A little polish to the carpentry, electric fixtures, and plumbing will soon see us done. The first step is to close in the walls. The south wall remains open until we can get photographs of the cabinetry and equipment installations. A quick eye will notice that although we are closing the walls, the water lines are left hanging in the ceiling. Actually, there's a good reason. The supply lines to the sink will be attached to the outside surface of the west wall. If there are later modifications, we can get to the pipes without tearing out any walls.

Now we attach the paneling and the ceiling tiles to their respective furring strips.

To seal out dust, we lay a bead of caulking compound along the joints between wall and wall, wall and ceiling, and wall and floor. Molding strips give the job a polished appearance.

We can now attach the diffusers to the ceiling lights. Safelight bulbs and filters are installed, and cover plates complete all the electric outlet boxes and switches. We hang the stereo speakers and plug them into the jacks. Now you know we're getting near the end. From now on we'll have the company of our sound system.

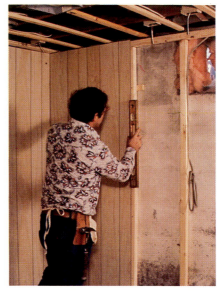

Only when all of the electrical and plumbing connections are complete, can we install the paneling.

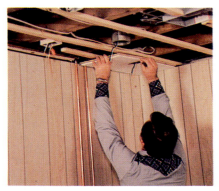

After completing the paneling, we proceed to install the ceiling tiles.

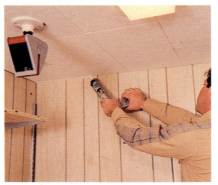

To make sure our darkroom does not allow stray leakage of light or air we caulk seams carefully.

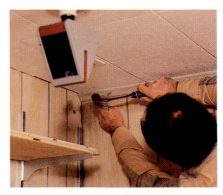

Mouldings cover the caulked seams.

Fitting the opal diffusers over the lamps completes the ceiling installation.

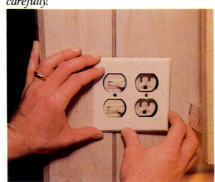

Cover plates over outlets and switches complete the walls.

The speakers for our sound system need only to be plugged in and hung in the places provided.

Those lonely hot and cold water lines are finally led down the surface of the west wall and connected to a pair of mixing faucets with unions. If you read the plumbing supply list carefully, you saw some things not yet mentioned. Thanks for your patience. The brass laundry tub faucet becomes a wall-mounted unit.

Our laundry faucet arrived from the manufacturer with three legs used to clamp over the sides of a laundry tub. The back leg even had a hole where a screw could lock the unit in place on the tub. We cut the two front legs off, but left the rear leg for easy wall mounting.

We completed the transformation into a wall-mounted tap by adding the street elbows, the one-inch-long nipples, and the brass drop-ear elbows.

This faucet, incidentally, is supplied with unions for wrench-only connection to the water lines. Had it not come from the factory so equipped, we would have used unions anyway so that we could later add a temperature control valve without resweating the joints.

Cabinets and Other Furnishings

Now the basics are finished. We have a room with lights and water. We need a place to put the enlarger and we'll have to have a sink. Storage room for film, paper, chemicals, trays, and a host of other things necessary to produce high-quality photography is a must. The following list contains some miscellaneous materials to help alleviate the storage problem. Others appeared in earlier lists when we made large orders from our supply houses.

MISCELLANEOUS MATERIALS

1 60-inch sink-base kitchen cabinet*
1 18-inch drawer stack-base cabinet*
1 30-inch-wide base cabinet*
4 feet of plastic laminate counter-top
1 18-inch wide x 30-inch-high wall cabinet*
1 30-inch wide x 15-inch-high wall cabinet*
1 36-inch wide x 15-inch-high wall cabinet*
8 2-foot shelf bracket holders
4 12-inch shelf brackets
4 10-inch shelf brackets
12 spring-type paper clamps, chrome plated
1 box of multi-colored plastic straws
2 small turn buckles
1 15-foot coil aluminum or rustproof wire
1 roll (25 feet) of ½-inch adhesive foam weather stripping
1 36-inch weather-tight doorsill with rubber insert
Odd-size scraps of foam-rubber-backed carpeting. Enough to cover all exposed cement floor.

*Purchased from a seconds outlet.

Our water faucet was converted from one intended to fit over a laundry tub. The text describes its conversion.

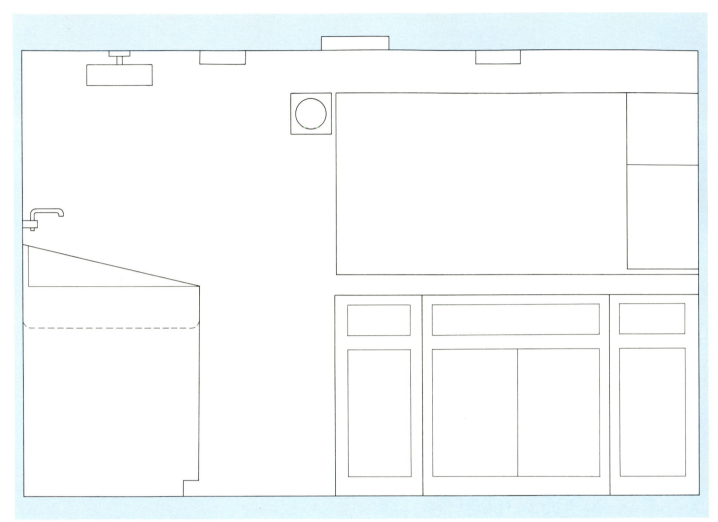

This drawing of the north elevation shows an end view of the sink to the left and a view of the printing area to the right. A 60-inch sink base is the main bench for the enlarger. The false drawer face is being replaced with a dark drawer (described on the following pages).

BUILDING A DARK DRAWER

In place of the false drawer front in the sink base we chose for an enlarger bench, we are going to install a dark drawer. The photograph at the right shows the finished drawer. The diagram on the next page makes some of the details easier to follow. Start by checking the materials list below. Many of the pieces are scraps that we had at hand. And, of course, we are making the drawer to fit the opening in our bench.

If you decide to make your own drawer, vary the dimensions to suit your own installation. Don't forget, however, to make the drawer to accommodate the paper sizes you normally use.

MATERIALS LIST

2 pieces of ¾ x 2½ x 24-inch clear pine

2 pieces of ¾ x 2½ x 20-inch clear pine (Note that ¾ x 2½ inches are the actual dimensions of a nominal 1 x 3. You can use cabinet grade plywood if you can find scrap pieces that you can cut to the width that you need.)

1 piece of 19 x 23 x ⅛-inch tempered pressboard

1 piece of 20 x 23 x ⅛-inch tempered pressboard

2 pieces of ½ x 1 x 20-inch maple or other hardwood

2 pieces of 1½ x 2½ x 22-inch maple or other hardwood

1 piece of 22 x 27 x ½-inch plywood

1 piece of 1½ x 8 x ¼-inch tempered pressboard

1 piece of 1½ x 6 x ¼-inch tempered pressboard

12 1-inch #4 flathead wood screws

16 ¾-inch #8 flathead wood screws

1 5-inch drawer pull. (We used the false drawer front taken from the sink base.)

1 small bottle of glue for wood and pressboard

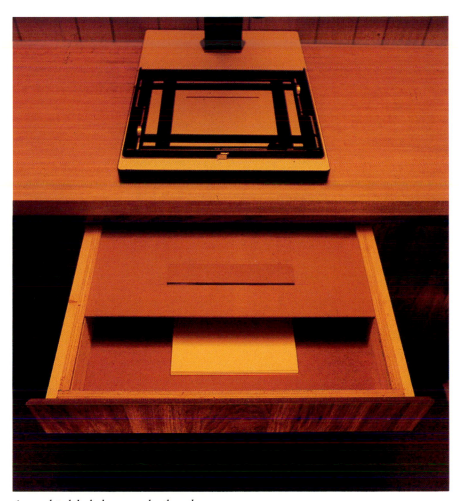

A completed dark drawer under the enlarger holds black-and-white paper ready for the easel. Note that we finished off our dark drawer with the false front that matched the other wood-grained doors and drawer fronts.

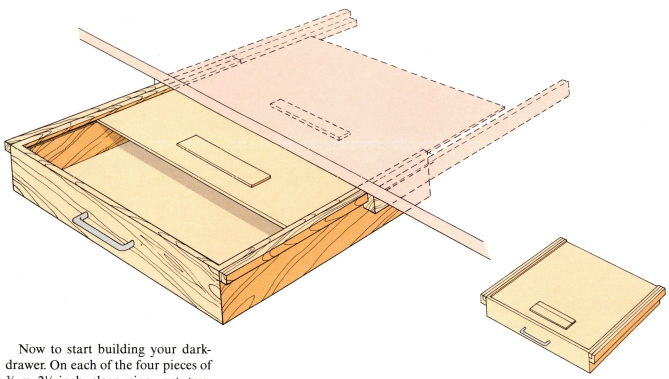

Now to start building your dark-drawer. On each of the four pieces of ¾ x 2½-inch clear pine, cut two, ⅛-inch grooves (dados), ⅜ inch deep, ¼ inch from each long edge on one side only. These grooves are for the bottom of the drawer and the sliding top. On the piece of ¾ x 2½ x 24-inch pine that you are going to use for the back of the drawer, cut one groove ⅜-inch from each end all the way through so that the top can slide in and out.

*The diagram **above** will give you an overall view of how the parts of the drawer fit together. The sequence of photographs **below** and **above right** follow the steps described in the text.*

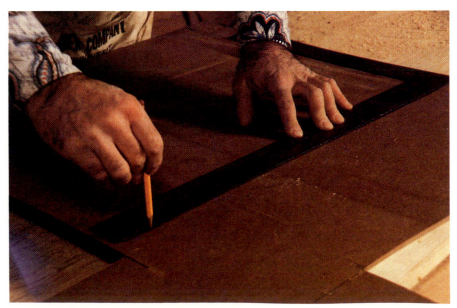

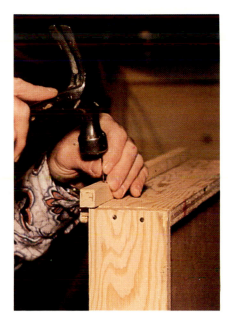

Finish off the drawer carefully so that the top slides easily in the drawer and the drawer moves in and out of the bench without sticking.

Cut a ¾-inch x ½-inch rabbet (channel) along the 2½-inch edge of each of the 24-inch pieces of pine.

Drill and countersink 3 pilot holes in each 2½-inch edge of the ¾ x 2½ x 20-inch pieces. Assemble the sides and bottom (⅛ x 20 x 23-inch pressboard) with glue and the #4 wood screws. The piece of pressboard for the top should slide in and out of the top dados smoothly. If it sticks, rub the edges with paraffin. Do not use silicone lubricant as it affects photographic film and paper adversely.

Attach the ½ x 1 x 20-inch maple glides on the 20-inch sides of the drawer flush with the top edge. Use glue and countersink four of the #8 wood screws. Be sure the screws are below the grooves in which the top slides.

Cut 1 x ½-inch rabbets in the top, inside long edges of the 1½ x 2½ x 22-inch maple pieces to accommodate the glides on the drawer.

Attach these pieces with glue and countersink four #8 wood screws along the 22-inch bottom edge of the 22 x 27 x ½-inch plywood, with the rabbeted groove at the top to form the tracks for the drawer glides to slide on.

Glue the 1½ x 6 x ¼-inch piece of pressboard to the sliding top pieces of pressboard 6 inches from the front edge and centered from the sides. Glue the 1½ x 8 x ¼-inch piece of pressboard to the underside of the plywood, 7½ inches from the front edge and centered from the edges. When the drawer is closed these two pieces of pressboard should engage, closing the lighttight sliding top.

Now attach the 5-inch drawer pull to the center of the front of the drawer to make it easier to open.

If you want to be very careful, you can paint the inside of the drawer flat black and even make felt lips for the inside of the grooves the top slides in. We have not bothered and have had no trouble during twelve years of hard use with this design in another darkroom.

MAKING A CUSTOM COUNTER TOP

To make a custom counter top, you attach a thin plastic laminate to a sturdy, rigid subsurface, such as particle board. We want to make a special-size counter top for the enlarger bench because the enlarger baseboard is deeper (28 inches) than the standard 24-inch preformed counter top.

Our carpenter trimmed the job down to size with expert organization and a sure eye. First he cut a piece of ¾-inch particle board to size (28 x 60 inches). Then he added an extra layer of particle board around the bottom edges to increase the rigidity of the counter top.

The next step is to cut plastic laminate strips for the edges that will show—the front and left sides. Contact cement permits no adjustment of the bonded pieces once contact is made. By cutting the plastic larger than the edges they're going to cover, the carpenter can be a little less precise about how he attaches the two. No mistakes this way. Using a latex-based contact cement (the fumes aren't explosive), he paints adhesive on the edges of the particle board and the underside of the plastic laminate. When the cement has dried

When he has prepared the counter top with double-thickness particle board at the edges, our carpenter prepares the edge surface with contact cement.

Cutting a strip of plastic laminate, the carpenter applies contact cement and attaches the strip to the counter edge.

to the suggested green color, he attaches the laminate to the edges of the particle board. Because he is an expert, our carpenter has not used a "slip sheet" of heavy paper between the laminate and the particle board while positioning the two. Since there is no room for error with contact cement, you would be advised to use the slip sheet if you are *not* an expert.

When the bond is firm—only a few minutes, he uses a router with special bit to trim and bevel the excess laminate.* The result is a clean, smooth edge. He hand-files the corner.

Once the edges are complete, the top surface of the particle board should be smoothed with a belt or orbital sander to make a better bond.

*You can do this with a file if you don't have a router or the special bit.

The carpenter uses a router with a special bit to trim and bevel the excess laminate (left deliberately so that slight misalignment is not critical).

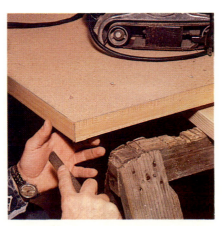

A file takes care of the finishing up. You can use the file for the entire edge if you do not have a router.

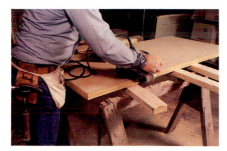

Preparing the top surface of the particle board with a sander is necessary to provide a better bond with the plastic laminate.

An inexpensive paint roller is handy for spreading latex contact cement on the particle board surface. The laminate gets the same treatment.

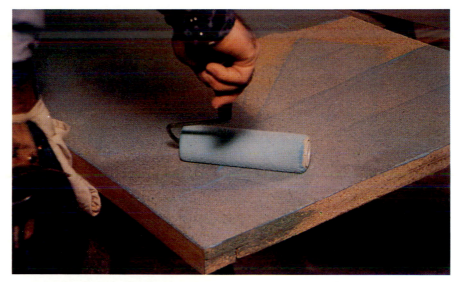

With an inexpensive (and disposable) paint roller, our carpenter covers the top of the particle board and the underside of the plastic laminate with the latex contact cement. Again, the plastic is sized larger than the particle board because the initial bond of the cement is quite final—once the two surfaces touch, there can be no adjustment for fit. By making the plastic surface a little larger, he can set it down on top of the particle board with some confidence, knowing that he can trim off the excess later. (As with the edges, use of a

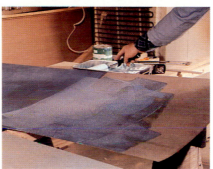

Our carpenter is an old hand at attaching the laminate to the particle board surface (see our comment on "slip sheets" in the text). Tapping with a hammer on a scrap of lumber disperses bubbles that might cause bumps in the finished top.

paper slip sheet between the surfaces to be joined allows adjustment of alignment before final contact.)

Tapping gently on a piece of scrap wood, working from the center out, disperses any air bubbles, ensuring a tight bond. Trimming off excess with the router leaves a smoothly beveled edge.

Now all that remains to be done is to set the top on the enlarger bench. We'll do that after we've completed the dark drawer. It's easier to work with all possible openings exposed.

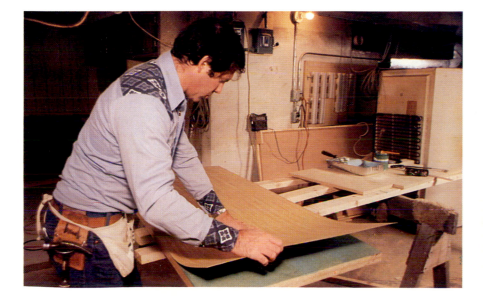

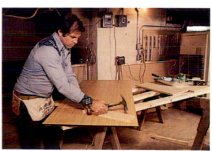

Under the boxed-in air pipes on the east wall, we attach a 15 x 36-inch horizontal wall cabinet to supply more closed storage.

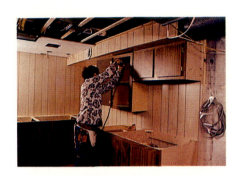

On the wall behind the enlarger bench we mount a piece of perforated fiberboard. This is great for hanging the timer, voltage regulator, lenses, and other small paraphernalia.

The south wall, **below**, *includes the doorway with the print drying rack to the left over the floor-level wall vents and the squeegee board to the right above the sink.*

THE SINK BASE

We have decided to buy our plastic sink without its metal pipe frame. Our plan is to build a base that would contain the sink and provide storage for trays and chemical bottles.

Our sink base is a custom fit for the ABS plastic sink we purchased. The base is designed carefully with darkroom needs in mind and so that it will completely fill the west wall. There's plenty of storage, and it's very sturdy.

The frame at the bottom is composed of 2 x 4s—strong and comparatively simple and inexpensive. The sides are constructed of ¾-inch plywood that fits the overhanging lips of the sink perfectly.

The lower storage shelves are constructed of ¾-inch plywood with rab-

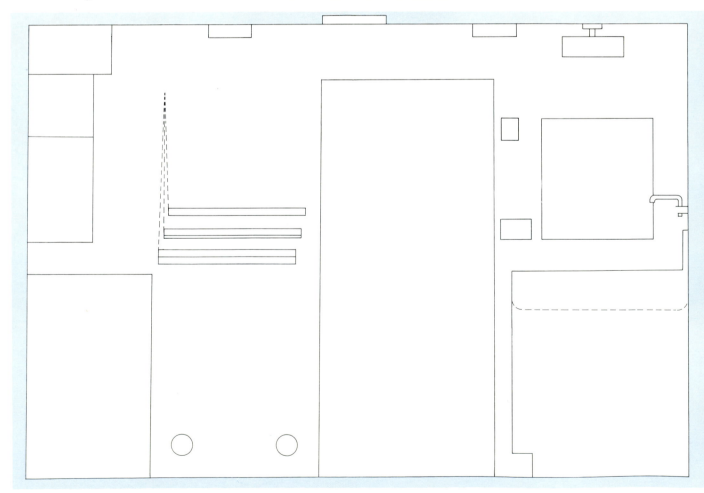

beted joints glued and nailed.

The tray racks on the right come to life rather like vertical, immovable drawers. Plywood with top and bottom dado cuts serve as the outside frame for ⅛-inch tempered pressboard dividers that keep the trays organized.

Drawer stack construction on the left side of the sink base is of plywood, pressboard, 2 x 2s, and 2 x 4s. The inside edges of the drawer sides have dado cuts on the bottom to hold the pressboard used for the bottom of the drawers. The side edges are glued and nailed. Glides come from a hardware store. Drawer fronts are pieces of thick plywood with a reverse bevel for appearance.

Finishing touches include a pro-

tective coating of paint and plastic laminate countertops for the two wings that hold the drawers (on the left) and the tray rack (on the right).

On the wall behind the sink, we mount shelf brackets that will allow us to place our shelves wherever most convenient.

At the left of the sink, we attach a 20 x 24-inch piece of particle board covered with plastic laminate to be used as a squeegee board.

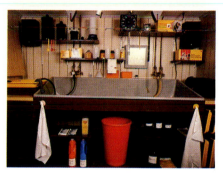

*The west wall, **below**, includes a drawer stack (with squeegee board above), sink, and tray storage racks.*

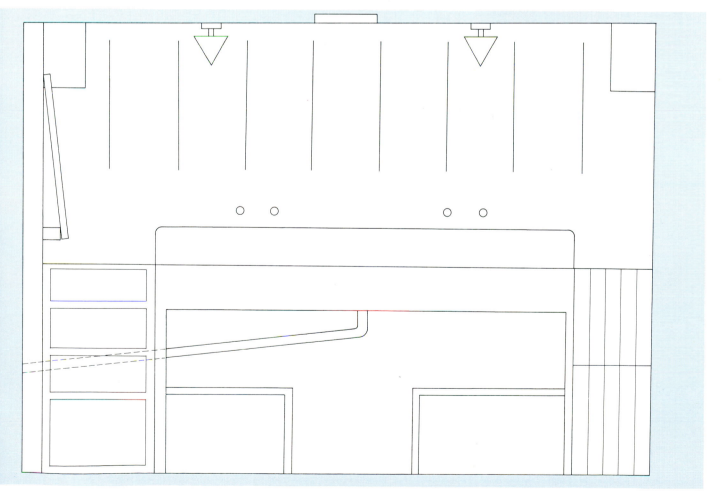

BUILDING A PRINT DRYING RACK

Next to the door on the south wall, we plan to have a print drying rack. To give us more room, we have designed it to fold up out of the way when it is not in use. Check the materials list on the opposite page, note the drawings to the right and on the opposite page, and follow the instructions and pictures below.

Using the six pieces of 1 x 1 x 24-inch pine and six of the 1 x 1 x 26-inch pieces of pine make three square frames. Glue and through-nail the 26-inch pieces into the ends of the 24-inch pieces with the 2-inch shake nails. These nails made for wooden shakes or shingles are galvanized steel or aluminum to prevent rust. Teeth along the sides help to prevent loosening.

On one side of each frame attach a corner bracket to each corner.

Turn the frames over and staple a piece of 26 x 26-inch screen to each one.

Along one edge on each frame four inches from each outside edge attach the two piano hinges with screws.

To mount the drying rack on the wall, find two adjoining studs in the wall (16 inches apart). Drill and countersink two holes 16 inches apart in the narrow edge of the 2 x 4, the 2 x 2, and the remaining 26-inch piece of the 1 x 1-inch pine. Offset these holes one inch from the right edge so when mounted on the wall the racks will be staggered (for handling convenience) as shown in the drawing.

Attach the 2 x 4 to the studs with the 6-inch screws, 36 inches above the floor. Attach the 2 x 2 to the studs with the 4-inch screws, 39 inches above the floor. Attach the 1 x 1 x 26 to the studs with the 3-inch screws, 41 inches above the floor.

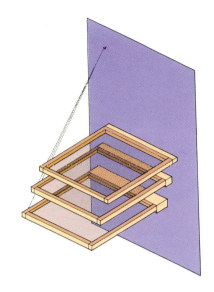

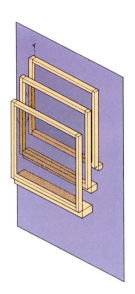

Attach a frame to each cross member with piano hinges, keeping the screen level with the cross member.

With the screw eyes, attach a piece of chain (about 3 feet) to each frame and then to the wall to hold the frame level, parallel to the floor.

Although the piano hinges are probably stiff enough to keep the frames upright and flat against the wall when not in use, you might want to secure them. Screw a hook into the wall and snub up the slack chains when the frames are upright.

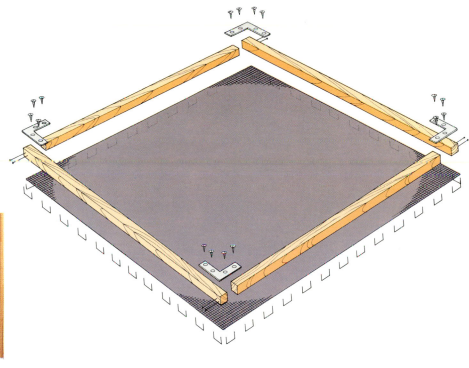

MATERIALS LIST

7 pieces of 1 x 1 x 26-inch clear pine

6 pieces of 1 x 1 x 24-inch clear pine
(These 1 x 1-inch pieces are ripped from 5/4 or "five quarters" nominal thickness lumber that is actually about 1-inch planed thickness.)

6 6-inch piano hinges and sufficient ¾-inch #6-screws

1 piece of 2 x 2 x 26-inch fir

1 piece of 2 x 4 x 26-inch fir

3 pieces of 26 x 26-inch plastic screen

10 feet of lightweight chain
(plastic-coated if available)

4 screw eyes for chain

12 flat corner braces with screws

2 6-inch flathead wood screws

2 4-inch flathead wood screws

2 3-inch flathead wood screws

12 2-inch shake nails

Wood glue (waterproof)

Staple gun and ¼-inch staples
(preferably stainless steel)

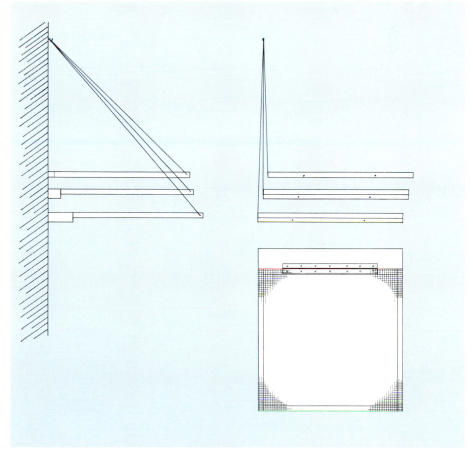

Near the floor in the south partition opposite the window fan we have mounted two 4-inch lighttight louvers to allow air to enter the room. We have sealed the partition just above these louvers with a 2 x 4 and on the outside of the partition we have framed a furnace filter, using 1 x 1-inch pieces of lumber.

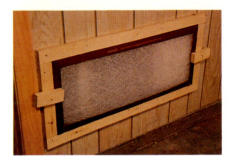

The drawing of the east elevation shows a side view of this drying rack and the storage base and cabinets on the east wall. We use a standard kitchen top on this base as we can utilize the 24-inch depth without difficulty.

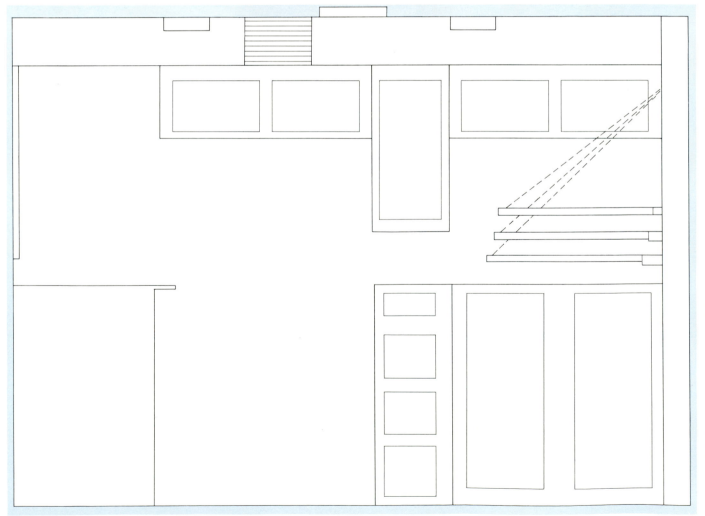

EXTRAS

Here are some extra touches we are adding to make our darkroom time more enjoyable; this will use up the rest of the materials we ordered.

With the plastic straws, paper clamps, wire, and turnbuckles we build a film drying line to hang over the sink.

Plastic towel holders can be purchased at most discount stores. Keep damp towels off counters where they can contaminate the work surface with unwanted chemicals.

Rubber mats or padded rugs are necessary in a basement darkroom. If you stand on a cement floor long enough your legs will become very tired. Get inexpensive rug scraps—they're easier to handle when you decide to mop the floor. (Some artificial fiber rugs cause static electricity problems in darkrooms unless specifically treated with an anti-static agent.)

There should be enough lumber scraps to build a small (6 x 8-inch) box. Mount a light socket inside this box and leave one side open. Place a 7½-watt red bulb in the socket and connect a line switch to the power cord. Over the opening of the box, attach a lith negative that says something cheerful like "BEWARE— DARKROOM IN USE" Or simply install a socket with a red bulb that can be turned on as a warning that the darkroom is in use.

The foam weather stripping and the weather-tight sill make the door lighttight.

A magnetic strip attached to the perforated fiberboard behind the enlarger will hold the dodging tools.

Finally! Our darkroom is complete and ready for operation. We really enjoy it, but it's fair to say that no two darkrooms are exactly alike. Each one displays some personal or special adaptations for combining the basic needs of electricity, water, ventilation, and other amenities in a lighttight environment. We hope that this book has established a sound basis to help you design and construct the darkroom that suits you best.

Paper clamps separated by plastic drinking straws customize our film drying line.

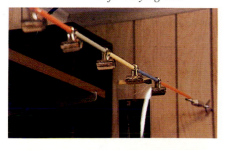

For comfort under foot, we like padded carpeting.

Around the door, we are using foam weather seal to exclude light.

The door sill is aluminum with a vinyl rub strip.

Towels are necessary, but they must be kept off counters. Use a towel holder like this one.

Real darkrooms

Here's a look at some darkrooms we have discovered—all designed and built competently without our help. We see some inventive problem solving, some sensible forethought, and some pleasing craftsmanship. All the building, incidentally, was performed by the owners.

Probably the first thing you'll notice about these working darkrooms is that they look a little cluttered compared to our pristine project darkroom. You may remember the brief discussion we had about storage space. There's never enough. All of these darkrooms have been used extensively, and we're seeing the appearance of a typical functioning environment. And in some cases, there has been a necessary compromise with other household operations.

DARKROOM— IN A LAUNDRY

Although the basement that serves as home for this darkroom is partitioned, the darkroom shares quarters with the laundry. It is a sensible arrangement, providing water, electricity, and drainage for both functions. Many of the darkroom fixtures were removed from an earlier house and adapted to this laundry room. The owner also had the foresight to add an extra course of blocks to the foundations walls when the house was built, giving extra height in the basement.

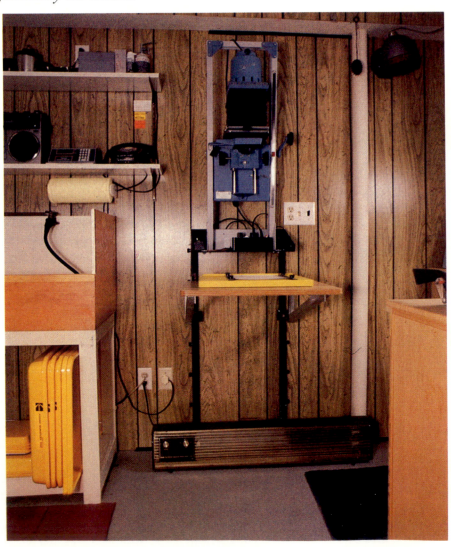

The electricity was planned out and established before the paneled walls and drop ceiling were completed. The plumbing, however, was run on the outside of the partitions—copper in and PVC out—to facilitate later changes. The pipes connect with the same lines used to supply the washing machine.

Safelight illumination comes from two large rectangular models one over the sink and the other bounced off the ceiling near the enlarger. An inspection light was rigged over the sink out of a retired safelight fixture with drawstring switch added. Overall illumination for the room is provided by two twin 48-inch fluorescent recessed fixtures. (Editor's Note: See our remarks on "afterglow," page 36.) Separate switches for the safelights and the fluorescent lights are found next to the enlarger.

The sink was planned and constructed by the owner out of marine grade plywood, waterproof glue, screws, and a layer of fiber glass and epoxy. It is watertight, convenient, and movable—it came from the first house. The duckboards, incidentally, were cut to size on a table saw and quickly assembled with waterproof

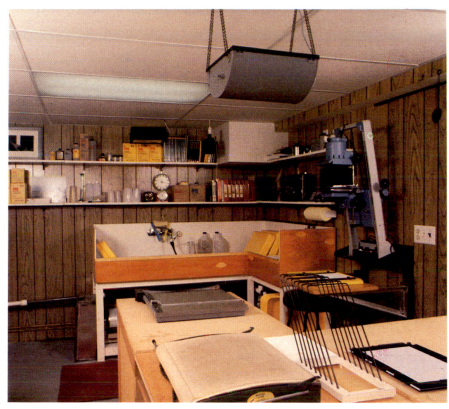

glue and wooden dowels.

The enlarger is fixed to the wall with a welded steel bracket that permits greater enlargement than the column of the enlarger will allow. The baseboard can be shifted down several positions, or removed for projec-

tions directly onto the floor.

A portable heater keeps this printer's feet warm and a freezer at the other side of the room keeps photo materials stable. Storage is found in convenient places all over the room. Shelves over the sink keep processing materials at hand and out of the reach of small children. Trays, processors, and other hardware reside beneath the sink. Perforated fiberboard holds objects that can be hung up out of the way. The two cabinets in the middle of the room contain enlarging supplies and support the trimmer, drier, illuminator, and extras. More storage is found on steel shelving at the end of the room, as is a slide illuminator. And, yes, there's still plenty of room to do the laundry.

DARKROOM— IN A GAME ROOM

This darkroom is integrated into a well-planned and spacious recreational basement. Notice the bowling machine and tennis table in the foreground. All the windows were blocked and the doors sealed to provide complete darkness for this color photo workshop. Without walls enclosing the darkroom area, there is ample room for family togetherness.

And it's fun to play table tennis or bowl in the shuffle alley while prints are being fixed and washed.

Wiring for the outlets, lights, and safelights was installed before the plasterboard walls and drop ceiling were finished. Some of the plumbing was already in position before the back wall was finished, and the mixing faucet was in good position to lead into the sink. The temperature-control valve was salvaged from its

original use for bathing show dogs.

The enlarger bench is a recycled kitchen cabinet that was removed during remodeling. With a little face-lifting, the cabinet provides space for a paper drawer on the top left and extra storage below. The bench was finished off with a custom-made counter top. The storage cabinet above and to the right of the enlarger also came from the old kitchen. A small unused bureau was the source

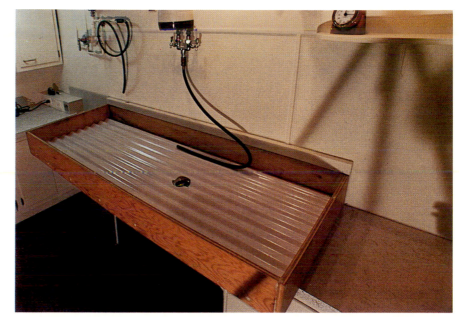

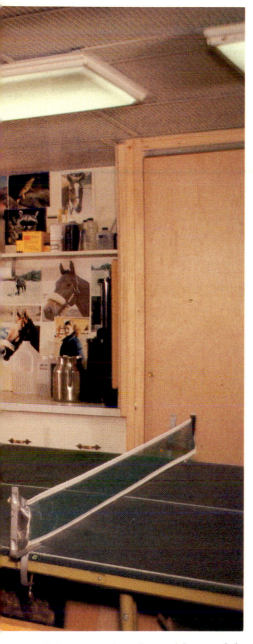

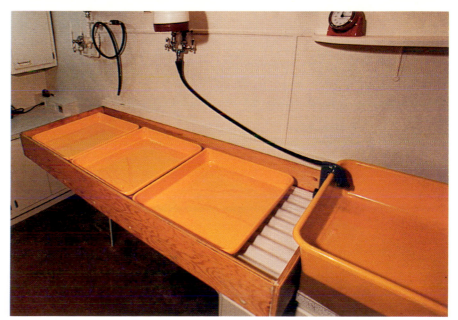

of drawers for the cabinet with counter to the right of the sink. It, too, has a new counter top, and the space below furnishes welcome storage.

The sink base for the removable wood sink is a converted laundry tub. The sink was constructed of ¾-inch marine-grade plywood with screws, waterproof glue, silicone crack filler, and three coats of epoxy finish. It doesn't leak and has shown no signs of wear. A corrugated fiber-glass panel provides a useful duckboard in the bottom of the sink.

One interesting aspect of this darkroom is the large space behind the sink that is used for displaying corrected prints. It serves as a diary of color adjustment and an instant visual reference.

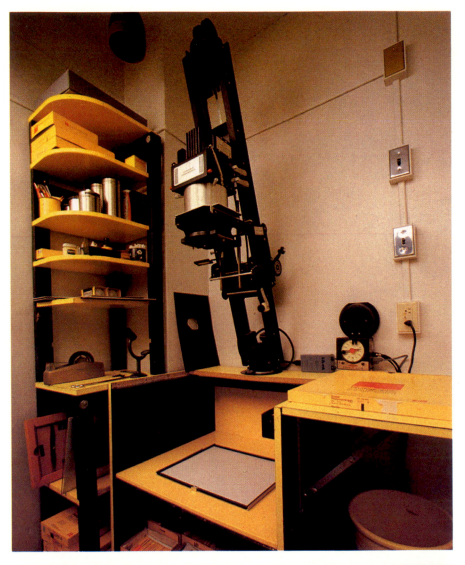

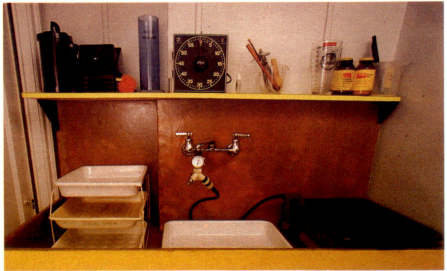

DARKROOM—IN A CLOSET

New York City apartments do not ordinarily lend themselves to darkroom work. One ingenious and ambitious photographer collected her resources and those of her friends to convert a fair-sized closet into a very efficient darkroom.

The left side of the closet became the wet side. Plumbing connects through the sidewall into the kitchen. The sink is a simple, functional design, constructed from 2 x 4s, ¾-inch marine plywood, fiber glass, and epoxy. Note the tall back-splash to accommodate a vertical tray-stack—necessary for the confined space and perfectly workable. Chemicals and trays are stored beneath the sink.

The dry side is so efficiently occupied that it gives an impression of far greater spaciousness. A floor-to-ceiling shelf stack holds miscellaneous equipment and spare parts in the top section. The bottom is devoted to easels, printing frames, and paper boxes. The enlarger is cleverly mounted on a bench that allows the baseboard to be lowered if necessary. Since full lowering to the floor happens infrequently, the space below the baseboard contains extra chemical packets and paper. (Naturally, because storage is quite crowded, this darkroom owner carefully tests the integrity of chemical containers to reduce the possibility of contamination.) The enlarger bench was constructed to a simple design from 2 x 4s and ¾-inch plywood covered with plastic laminate. Don't miss the handy drop-leaf counter at the near end of the unit.

Electricity was supplied from the two original closet ceiling fixtures. The builder added more white light with two more ceiling fixtures. A parallel line with separate switches for four safelights fits in the white light conduit. Notice that both safelights over the wet side are in use,

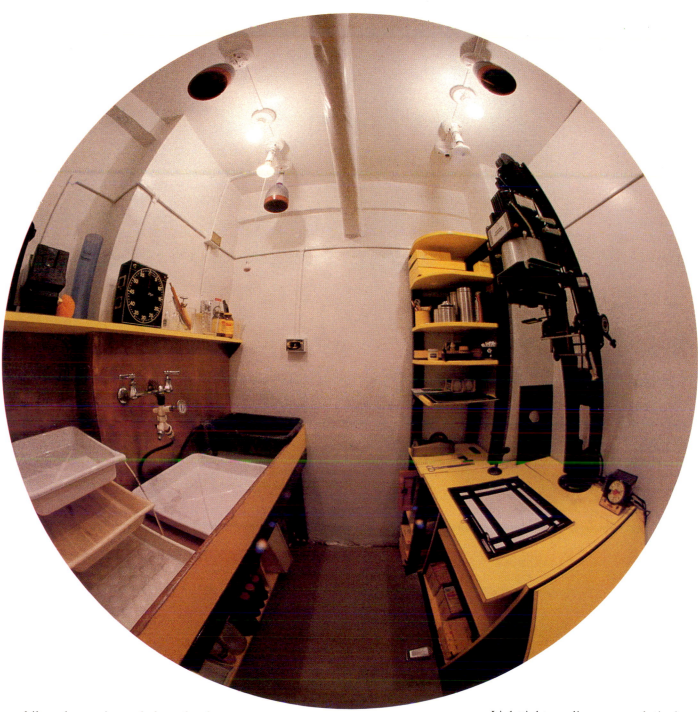

while only one is needed on the dry side. Outlets have been dropped from the appropriate overhead lines to both wet and dry sides and to the back of the room. The wet side outlets stay above the top of the splashboard. Separate light switches are located sensibly next to the enlarger.

Lighttight sealing was relatively easy since there were no windows. Each of the two door frames was ringed with weather stripping. Closing the door tightly requires substantial pressure—enough to ensure that the darkroom user will make a conscious effort to shut out the light.

DARKROOM—
IN A HOBBY CENTER

This basement darkroom shares space with a family project and hobby center, the laundry, the workbench, and a plant-growing area. The first step was to completely darken the entire basement with black cloth over the windows, a light baffle for the furnace firebox, and a lip for the upstairs door. Extra safety is provided by working at night.

Safelights were hung on the ceiling in appropriate places and wired into boxes in the ceiling. You'll notice that

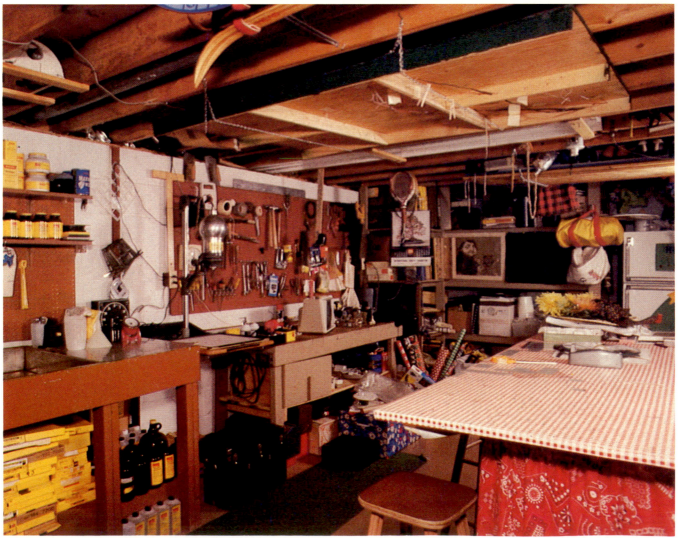

the ceiling also serves as storage for skis and other items.

The sink was constructed out of 2 x 4s and a salvaged stainless steel sink with counter. The photographer, incidentally, emphasized that photographic quality stainless sinks (Type 316 or 316 LC) are a must if you are going to use metal. An earlier kitchen transplant failed miserably with constant exposure to photo chemicals. Hot and cold water were drawn off lines leading to a bathroom and led into a mixing valve that was salvaged from a dismantled processing lab. All the plumbing was done with PVC plastic pipe. It was easy to work with, and relatively inexpensive. A later addition to this sculptured plumbing arrangement was an irrigation line for the plant area to the left of the sink.

The enlarger is mounted on a welded-steel wall bracket that allows the baseboard to be dropped to various positions approaching the floor. Since this photographer prefers to work in black-and-white, there is no provision for voltage regulation to the enlarger. (Editor's Note: For reproducibility of results, we recommend a voltage regulator even for black-and-white printing.)

Materials for the darkroom are stored on the floor, on the shelves attached to the perforated fiberboard behind the sink, and inside the sink base.

Although the darkroom is constantly exposed to the entire family and all the other basement functions, including the laundry, the owner claims no significant dust or dirt problem. The basement is dry and warm enough for comfort. Notice the strip of carpet in front of the sink and enlarger.

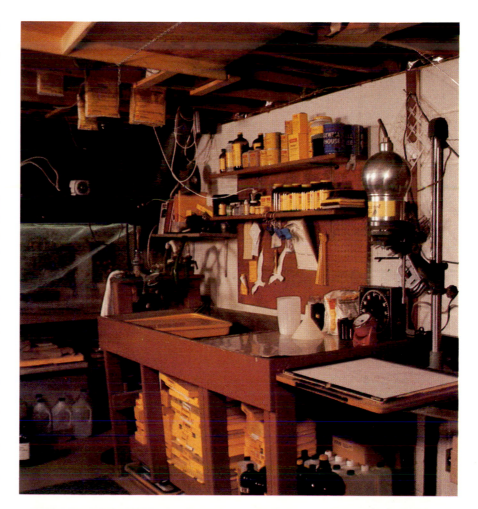

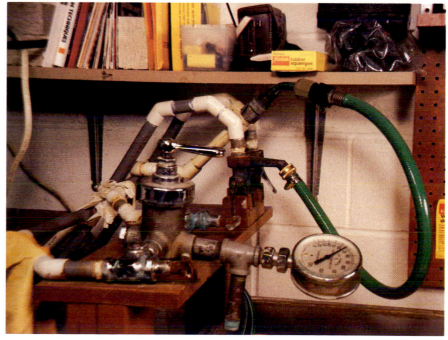

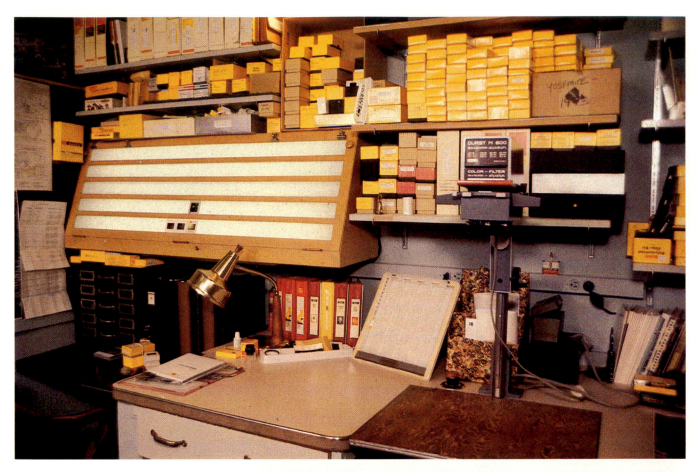

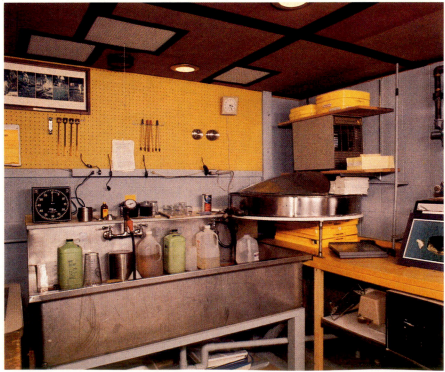

DARKROOM—
ON ITS OWN

Partitioned off from the rest of the basement, every cubic inch of this area is in use. Beyond color and black-and-white printing, this photographer makes movies, creates slide presentations, and stores all related material in his darkroom.

The handy corner was at the bottom of the stairs, in the opposite direction from the finished family room. The space was originally good for storage but not much else. Fortunately, electrical circuits and plumbing were available nearby, so that installing the sink, the stainless steel washer, the sophisticated illumination system, and the abundant outlets was a relatively easy task. The owner recessed all the lighting in the ceiling before dropping in the tiles. Electricity to the outlets, however, is supplied on the wall surfaces.

The owner created most of the furniture as well as the room itself. Notice the two-position enlarger baseboard, which is an integral part of the enlarger counter. Also notice how the unusual girder construction of the enlarger bench permits easy access to the storage below. Shelving occupies all otherwise unused space, and it's all necessary. Perforated fiberboard, framed and attached to the cinderblock, is immediately accessible above the sink. Because this photographer prefers to view slides from a standing position, the illuminator was attached directly to the wall.

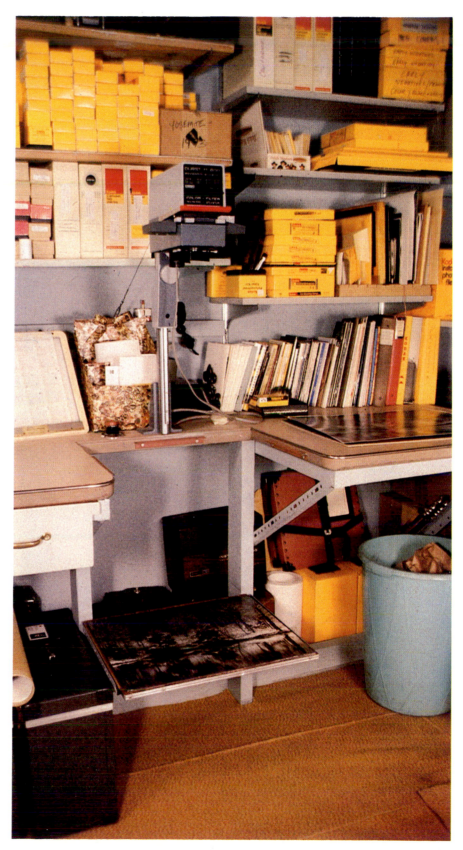

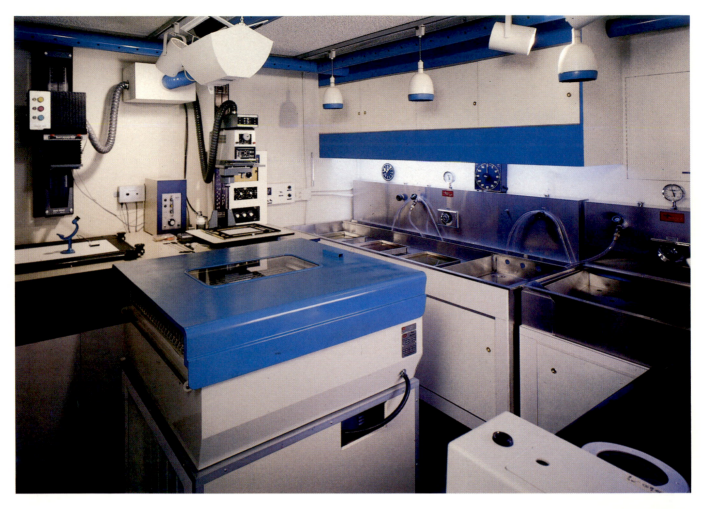

DARKROOM— IN A BEDROOM

This modular darkroom in an 8 x 10-foot bedroom was designed by a busy free-lance photographer who works out of his home. Based on his 30 years of experience, this photographer incorporated futuristic applications of readily available technology. This lab is equipped to handle a wider range of materials and is more productive than a previously owned lab six times its size.

Construction requirements included not altering the existing bedroom structure. Plumbing was available from an adjoining bathroom. All units were constructed with hand tools—electric circular saw, router, and the other usually available craftsman's kit. All the nonphoto-

graphic gear, even the air conditioning system and duct work were from a large catalog supplier. Note that the overhead air distribution ductwork is actually perforated PVC drainpipe available from the same source.

The photographic equipment also includes readily available lab units. Two enlargers, a dryer for resin-coated papers, a densitometer, and a tube processor capable of processing both black-and-white and color materials are the major pieces.

The lab design includes flexibility, serviceability, and construction ease. Should the lab need to be moved to another location, all that would be required is to unbolt various sections, dismantle the track lighting system, and uncouple the plumbing at carefully provided unions. Reversing the

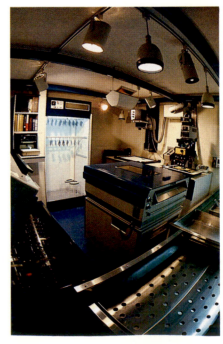

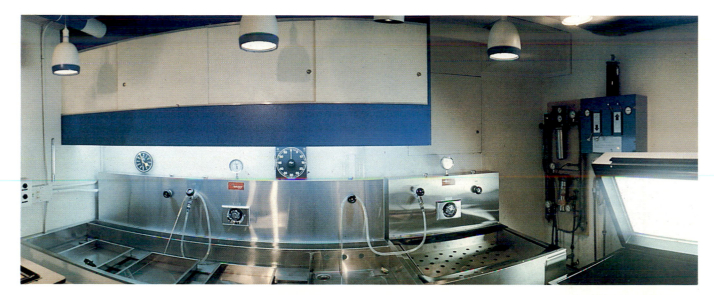

process would have the lab operational at a new location within a day.

Water for the entire lab is filtered at the inlet. Taken from existing room supply, the electrical system includes a multi-channel track that allows the same track to be used for safelights as well as for white lights. Also included is a focusing spotlight on the track over the first wash tray; this spotlight is controlled by an ordinary room light dimmer.

With the exception of installation of the floor sink and connection of a 60-amp, 240-volt connection for the dryer, all of the construction work was performed by a teenage student under the direction of the photographer-designer. With lab completion, much of the lab processing work was done by another neighborhood teenager.

All of the lab equipment is integrated to work together. Even the uniform color scheme bears out the designer's attention to detail. The lab is self-cleaning. The busy free-lance photographer can leave the lab after a day's production to go on location with the knowledge that the lab will be completely ready to process his film when he returns.

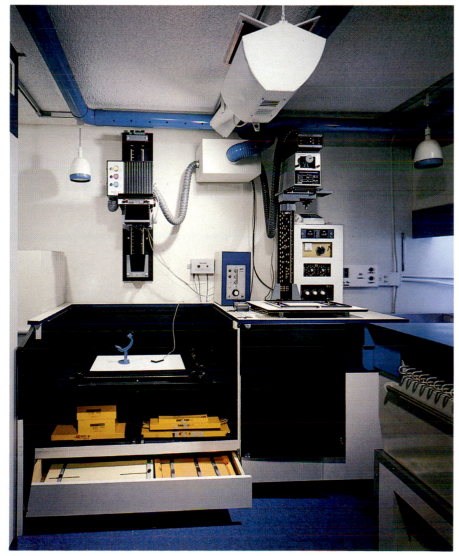

DARKROOM—
HOME PRODUCTION FACILITY

Here is the author's personal darkroom area and retreat. It is a sophisticated, carefully planned miniature production facility where a commercial-industrial photographer can perform nearly any operation with ease and dispatch. Whether printing or processing color or back-and-white film or paper in a number of sizes and formats, the user can carry out each step in a well-organized manner with no wasted movements and few accidents.

Many of the ideas incorporated in this mini-lab appear in our project darkroom. Let's take a look around.

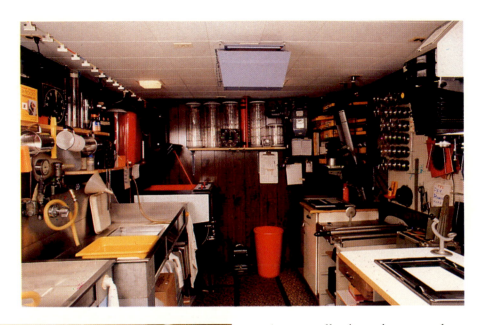

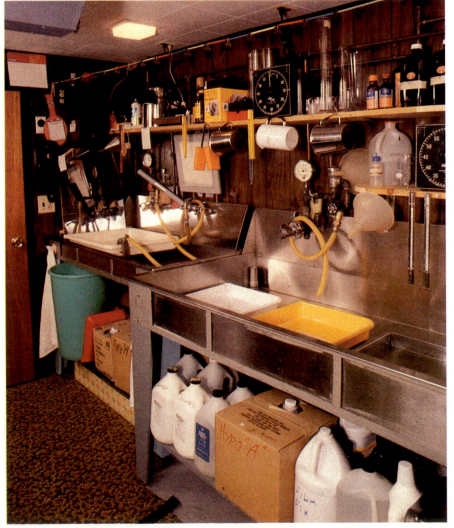

An overall view shows a clear division of dry and wet sides. They're about as far apart as possible, separated by a carpeted aisle. On the wet side are two sinks—the larger one used for tray processing, and the smaller one for a permanent wash station. At the near end, looking back at the door, the safelight and white-light switches are visible—at different levels to avoid costly mistakes. You can also see one of the stereo speakers, a handy telephone extension and stainless steel squeegee plate above the wash tray. A single shelf runs the length of the wall above the sinks, permitting storage of timers, chemicals, graduates, and more. Hooks in the face of the shelf offer instant access to small tools.

Plastic towel holders at three points give the operator no excuse for wet hands. Over the sinks you will see a familiar sight—the film drying line made from cable, turnbuckles, plastic straws, and paper clamps. The main location for bottled chemicals is under the sinks. Notice how electricity on both sides of the room is supplied from the ceiling. The outlets, incidentally, for this installation are ceiling outlets that have better grippers for suspended plugs.

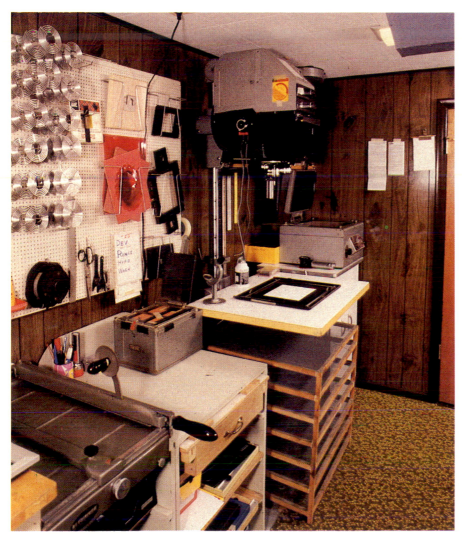

The 8 x 10-inch contact printer (which is also handy as a negative-transparency viewer) is at the far right.

Safelight illumination is provided by an 11 x 14-inch Thomas Mercury Vapor Safelight suspended from the ceiling and aimed upward to reflect from the ceiling. Additionally, doors on the side of the safelight swing open for more direct light when needed. Incidental illumination is given over the trimmer. White light comes from the recessed fixtures in the ceiling. As with the model darkroom, electricity comes from several unburdened circuits, allowing the enlargers and the processor stable sources of power.

Outside the room, we find a refrigerator for film and paper on one side of the door and the chemical mixing bench on the other. Handling photo chemicals outside the darkroom lowers the chance of contamination. The appliances you see are a still to provide distilled water, a magnetic mixer for chemical batches up to five gallons, and a blender for batches up to one quart.

At the far end of the wet side, you'll see the processor that can handle film or paper. Basically, it operates like a giant tube processor, except that timing and temperature control operations are built in.

All the water for the wet side comes from the ceiling in exposed pipes. All the hookups were completed with unions that can be easily separated if there is need for repair or replacement. Outside the darkroom, there's an efficient water filter. Drainage takes place through a single PVC pipe that enters the partition at one place and exits through another, thus creating a lighttight baffle.

The dry side is a model of efficiency. Since the photographer-au-

thor works in formats from 35 mm to 8 x 10 inches, there are two enlargers. At the back of the room, wall-mounted steel shelving holds black-and-white paper next to the small-format enlarger. This enlarger stands on a small cabinet at a comfortable height. The paper safe drawer is between the enlargers in the trimmer bench. Enlarger accessories are hung on an adjacent perforated fiberboard or stored in the cabinet that supports the trimmer and a contact printer—at a lower height, you'll notice.

Nearer the door stands the 8 x 10 enlarger. The print drying rack rests out of the way under the adjustable baseboard. Both timers, incidentally, are connected to voltage regulators.

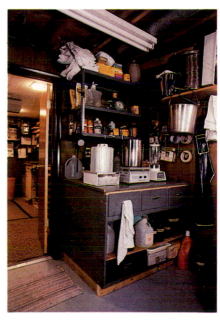

Recommended reading

About the only thing now lacking in your project darkroom is some exciting photography projects. Surely you have been saving quite a number and planning more as you've put the final touches on your darkroom.

You may find that you want some additional knowledge to get started in the right way. Kodak books will help you to polish your photographic skills to learn entirely new disciplines so that you can fully appreciate your new sanctum. Some books describe basic or advanced techniques and some give great detail about the characteristics and use of Kodak products. Review the list that follows to see if there's something that will help you in the darkroom.

Ask your photo dealer for these publications. If your dealer cannot supply them, you can order by title and code number directly from Eastman Kodak Company, Department 454, Rochester, New York 14650. Please enclose payment with your order, including $1.00 for handling plus applicable state and local sales taxes. Prices are subject to change without notice.

Photolab Design (K-13)
$2.00
An advanced manual for the professional photographer, custom photofinisher, or photo instructor for remodeling an existing photolab or designing and building a new facility.
8½ x 11 inches, 53 pages.
ISBN 0-87985-098-1

Color Printing Techniques* (KW-16)
$8.95
Color printing is easy, fun, and predictable. Follow the straightforward instructions of this book to become a master color printer. Useful and logical information on printing color negatives and color slides.
8½ x 11 inches, 96 pages.
ISBN 0-87985-275-5

Black-and-White Darkroom Techniques* (KW-15)
$8.95
This is a basic book with far more than basic information. Starting with fundamental procedures, the heavily illustrated, clear text leads the reader into a critical understanding of the black-and-white medium.
8½ x 11 inches, 96 pages.
ISBN 0-87985-274-7

**Kodak Workshop Series*

Enlarging with KODAK B/W Papers (G-1)
$10.95
Provides a better understanding of paper characteristics that contribute to the finest print quality.
ISBN 0-87985-279-8

KODAK Black-and-White Darkroom DATAGUIDE (R-20)
$12.95
This favorite darkroom reference contains major sections on black-and-white films, enlarging papers, and chemicals. The most comprehensive black-and-white DATAGUIDE ever assembled by Kodak.
7¾ x 8¾ inches, 34 pages.
ISBN 0-87985-269-0

KODAK Color Darkroom DATAGUIDE (R-19)
$14
Good reference guide for the color darkroom. Gives extensive data about the exposure, processing, and printing of color darkroom materials. The color companion piece for the KODAK Black-and-White Darkroom DATAGUIDE discussed above.
7½ x 8¾ inches, 32 pages.
ISBN 0-87985-086-8

**Introduction to Color
Photographic Processing** (J-3)
$5.75
Gives extensive and current information for advanced amateurs and beginning professionals about processing color films and papers.
8½ x 11 inches, 52 pages.
ISBN 0-87985-216-X

Creative Darkroom Techniques (AG-18)
$9.95
This is an advanced book covering a wide range of darkroom techniques from methods of contrast control to photo silk-screen printing. Many ways to make exciting new photographs from existing negatives and slides. Almost 400 illustrations in color and black-and-white.
Hardcover, 6 x 8¾ inches, 292 pages.
ISBN 0-87985-075-2

Preservation of Photographs (F-30)
$5.50
Repairing deterioration that has already taken place and improving storage conditions of photographic collections are just two of the topics discussed in this book. Although written primarily for those who have charge of storing negatives and prints, it will also be helpful for those who are concerned with processing.
8½ x 11 inches, 60 pages.
ISBN 0-87985-212-7

Photo Decor (O-22)
$8.95
This book tells how to use photography to enhance your surroundings, both at home and at work. Designed primarily as a handbook for professional photographers, interior designers, and decorators, the book will also be of great help to the do-it-yourselfer who simply wants to enjoy beautiful photographs as decoration. Contains more than 250 color and black-and-white photographs offering many new ideas and suggestions.
8½ x 11 inches, 88 pages.
ISBN 0-87985-220-8

**Basic Chemistry of
Photographic Processing** (Z-23-ED)
$5.00
Two programmed instruction booklets introduce the photography student to basic concepts in the preparation and use of processing solutions.
8½ x 11 inches,
Part I, 35 pages; Part II, 43 pages.

**Processing Chemicals
and Formulas** (J-1)
$1.95
Presents recommended black-and-white processing techniques and Kodak formulas.
8½ x 11 inches, 52 pages.
ISBN 0-87985-069-8

**Basic Photographic
Sensitometry Workbook** (Z-22-ED)
$6.50
An introduction to basic photographic sensitometry for photographers, graphic arts camera operators, students, teachers, and all other users of photographic materials.
8½ x 11 inches, 40 pages.
ISBN 0-87985-290-9

Prices shown are suggested prices only and are subject to change without notice. Actual selling prices are determined by the dealer.

Index